lovely kids with lovely pets coloring book

A coloring book for adults showing the love and compassion between kids and animals in charming scenes with beautiful frames for more coloring.

Copyright 2019 © nader raft
All Rights Reserved.

Disclaimer

All right reserved. No part of this publication or the information

in it may be quoted from or reproduced in any form by means such

as printing, scaning, photocopying or otherwise without prior

written permission of the copyright holder

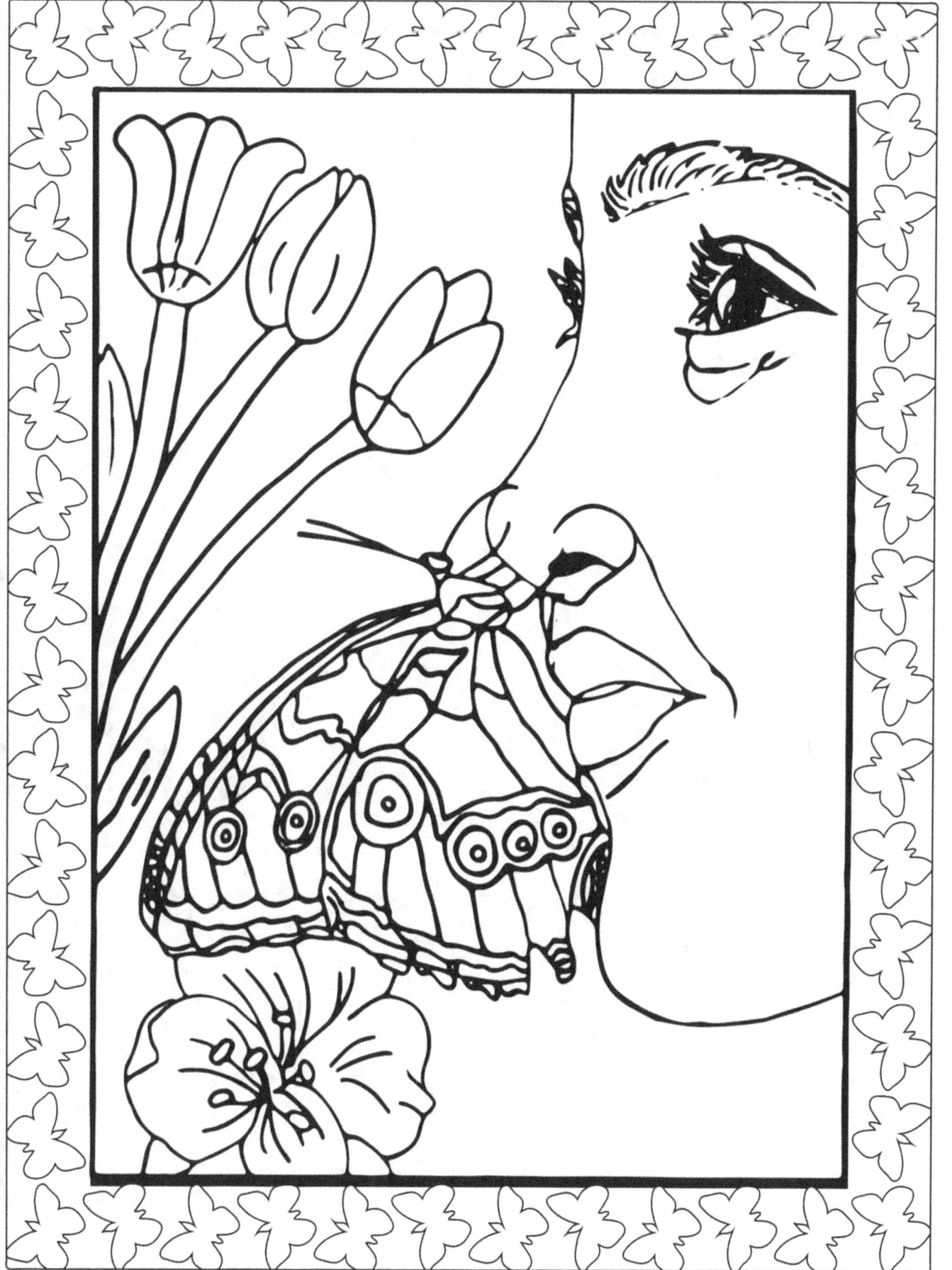

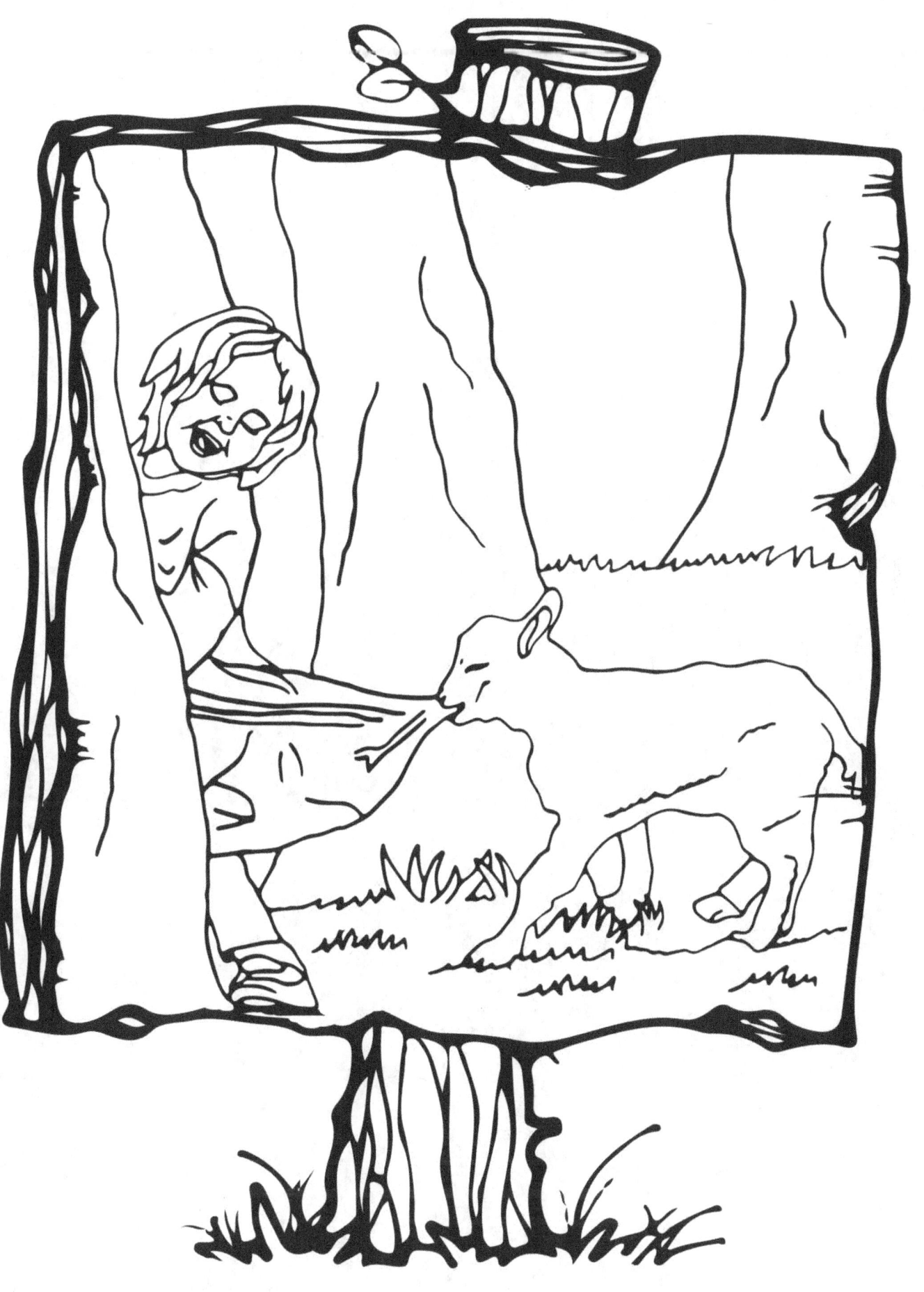

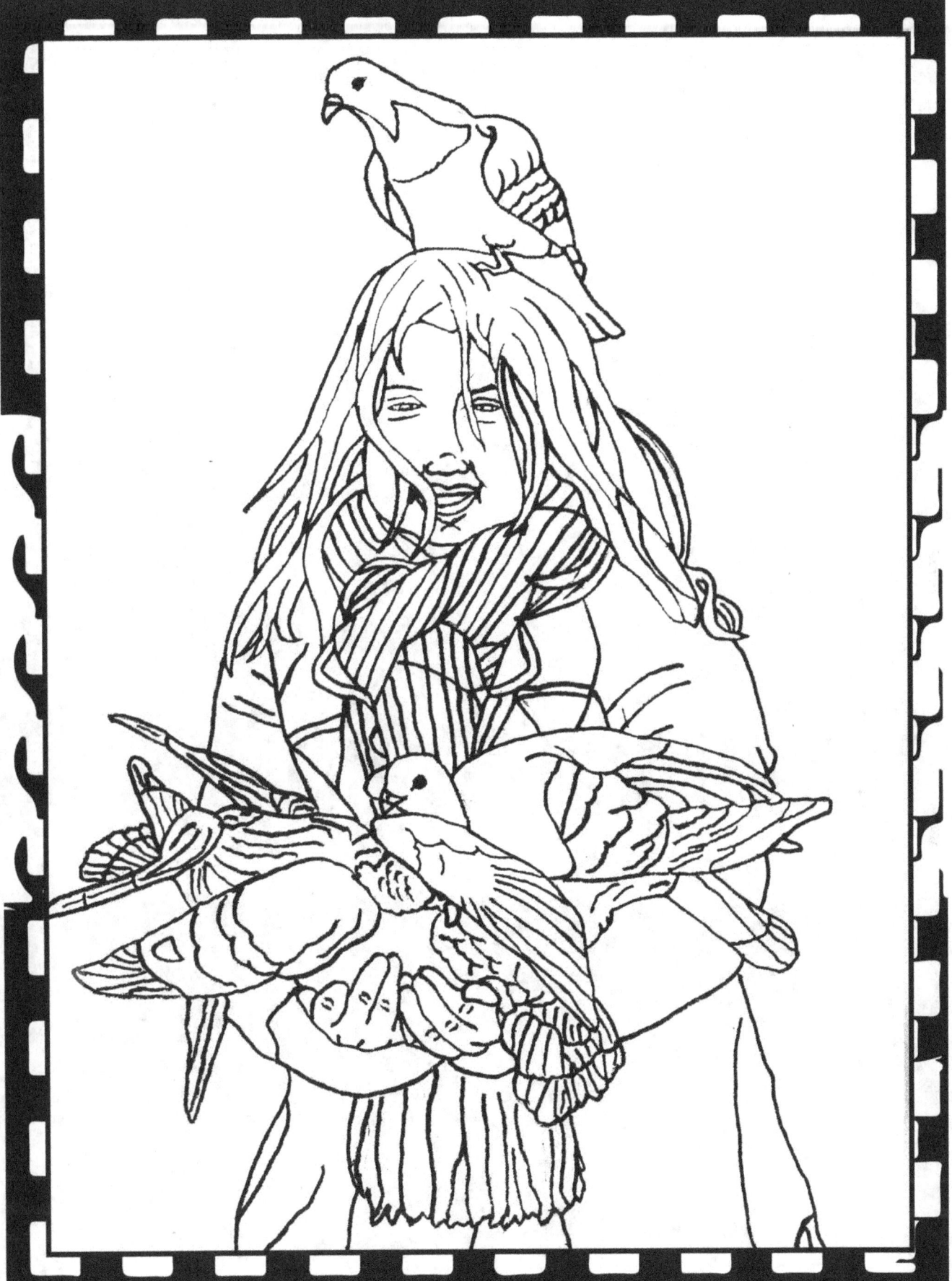

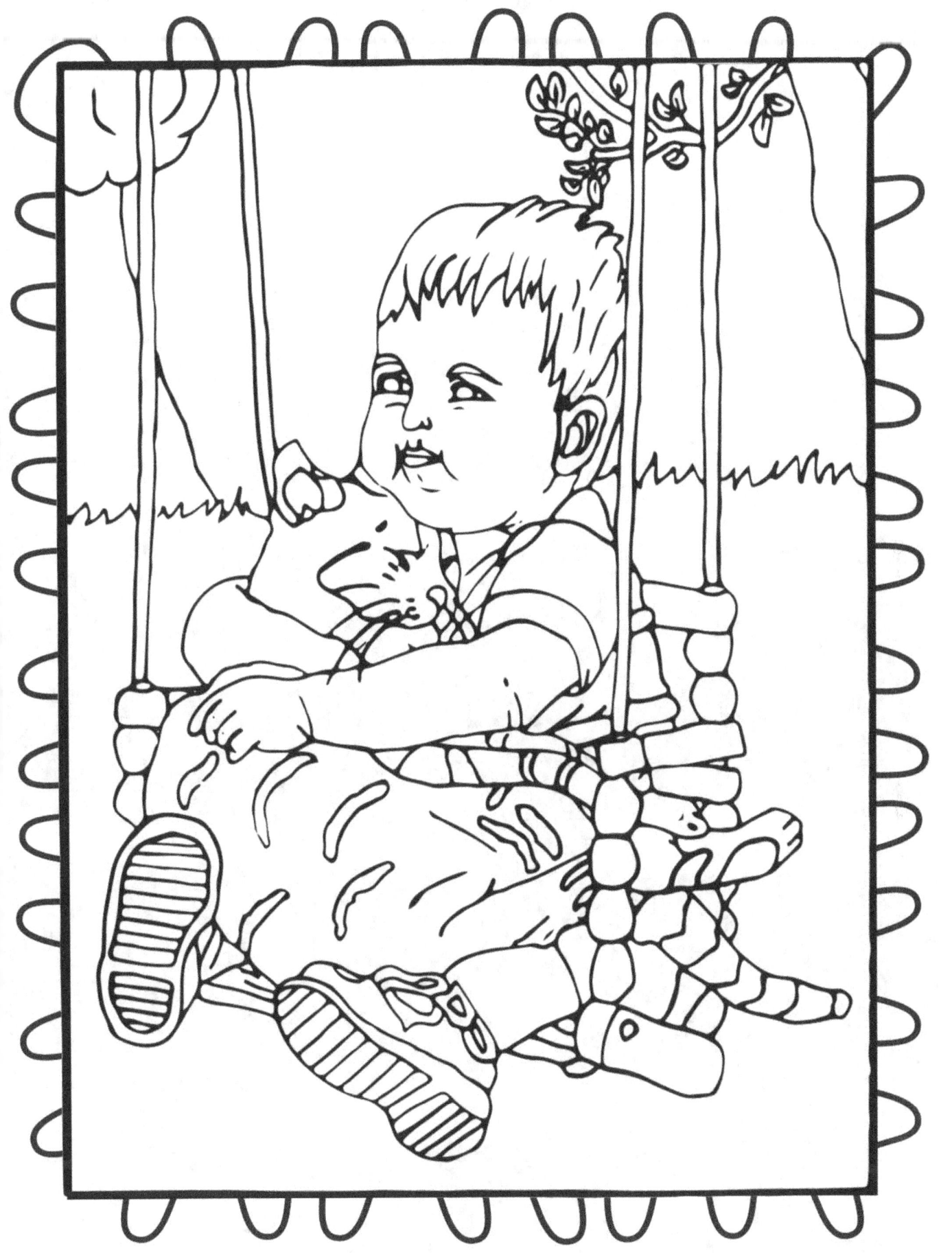

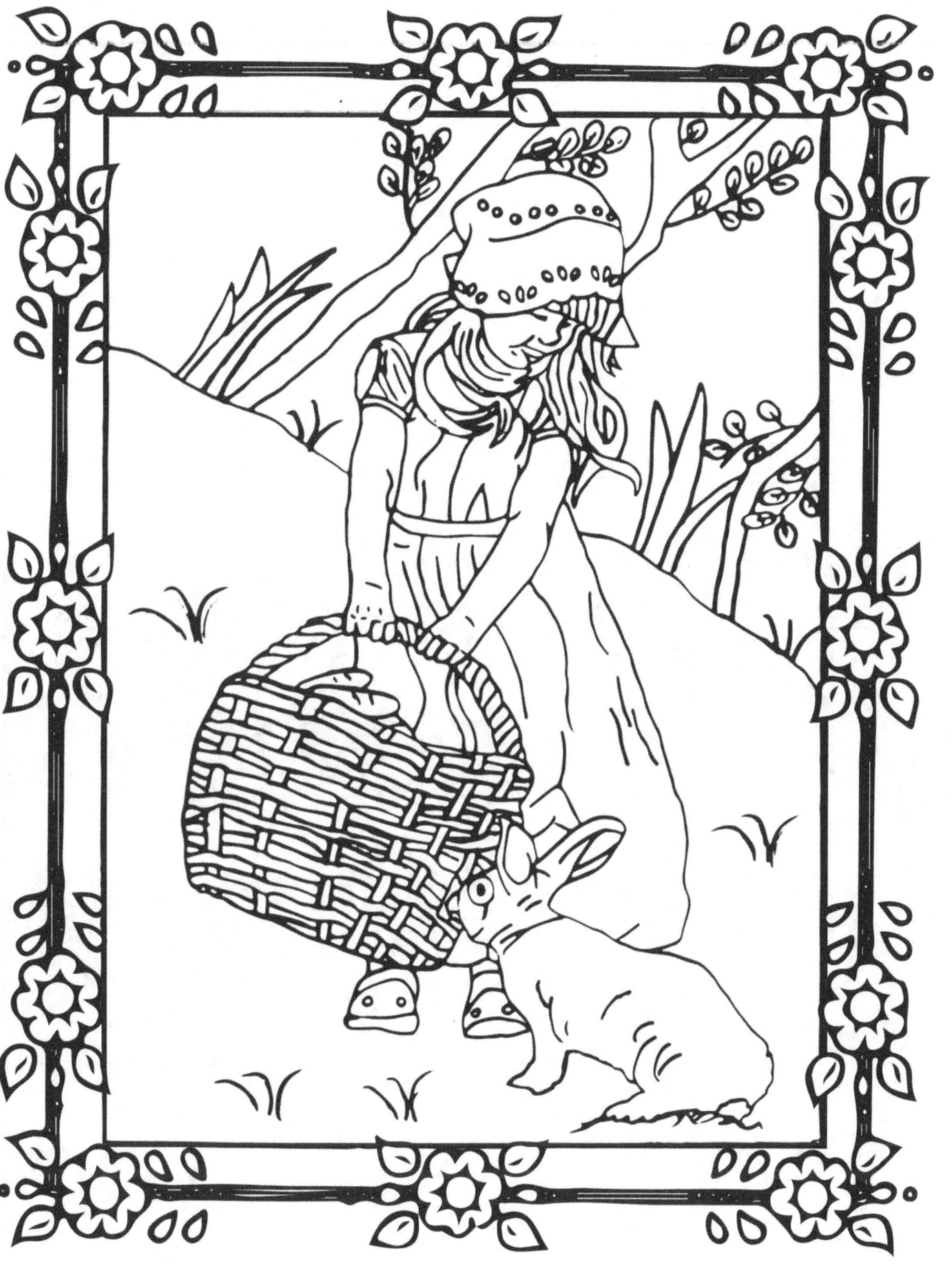

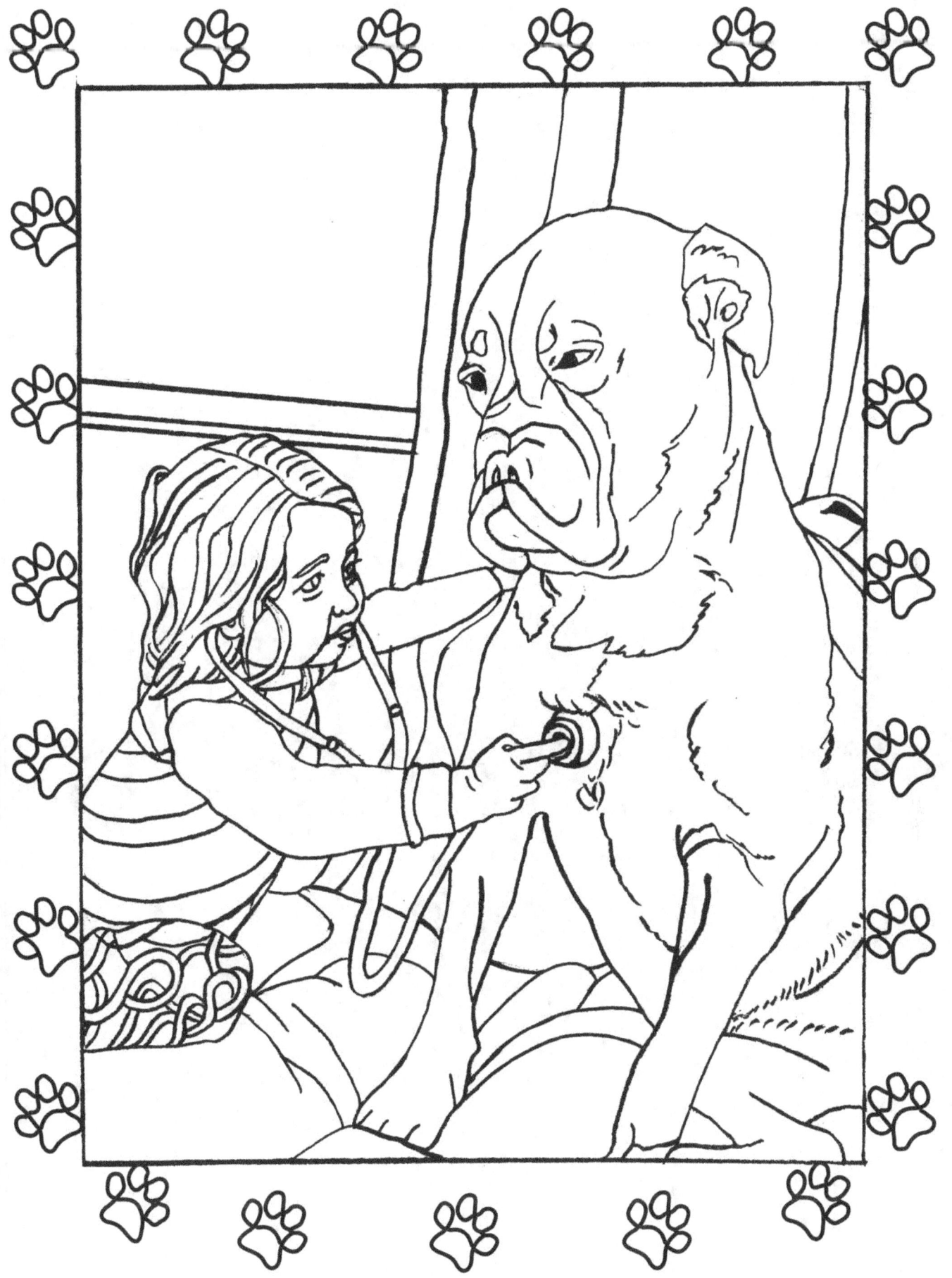

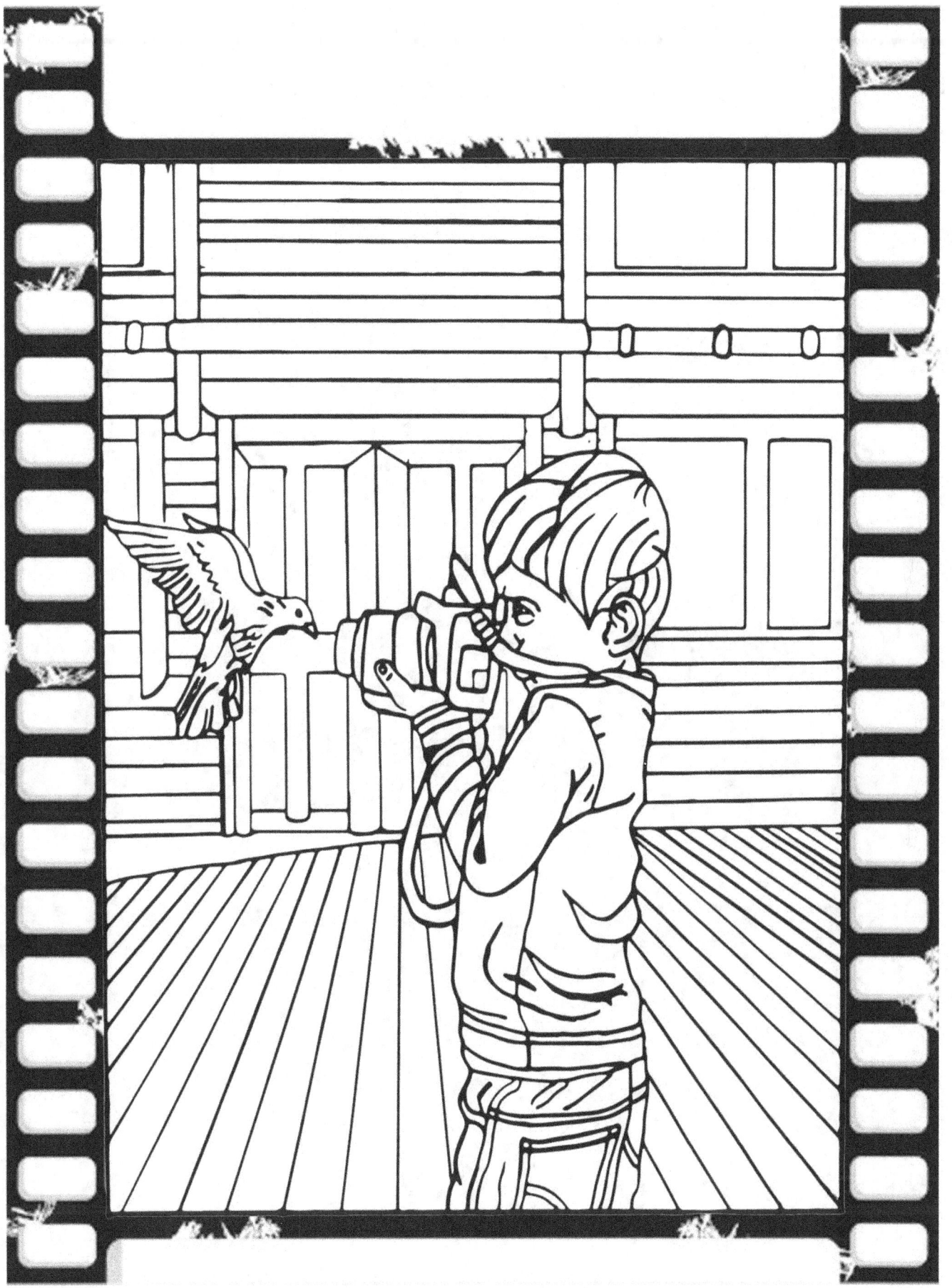

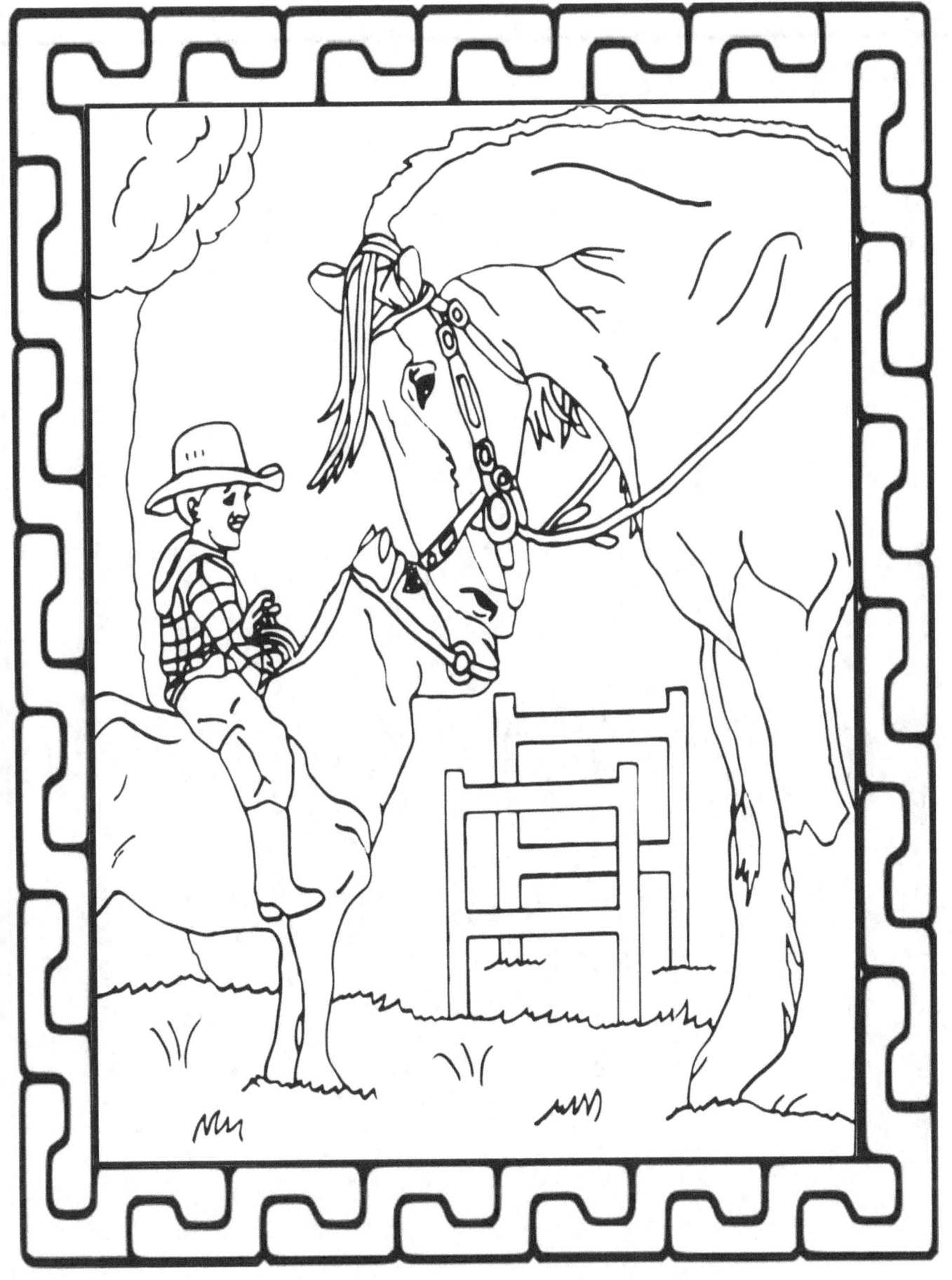

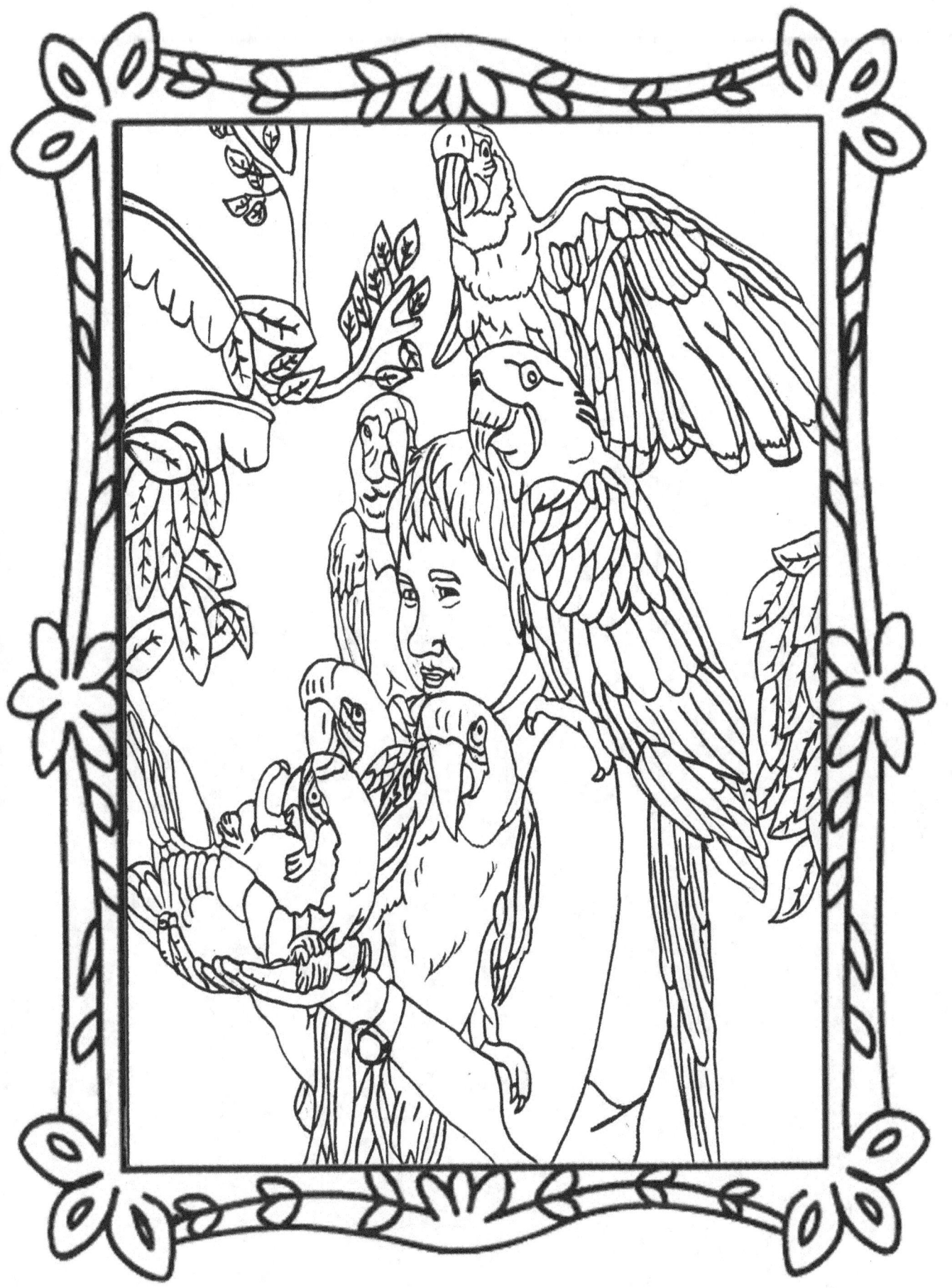

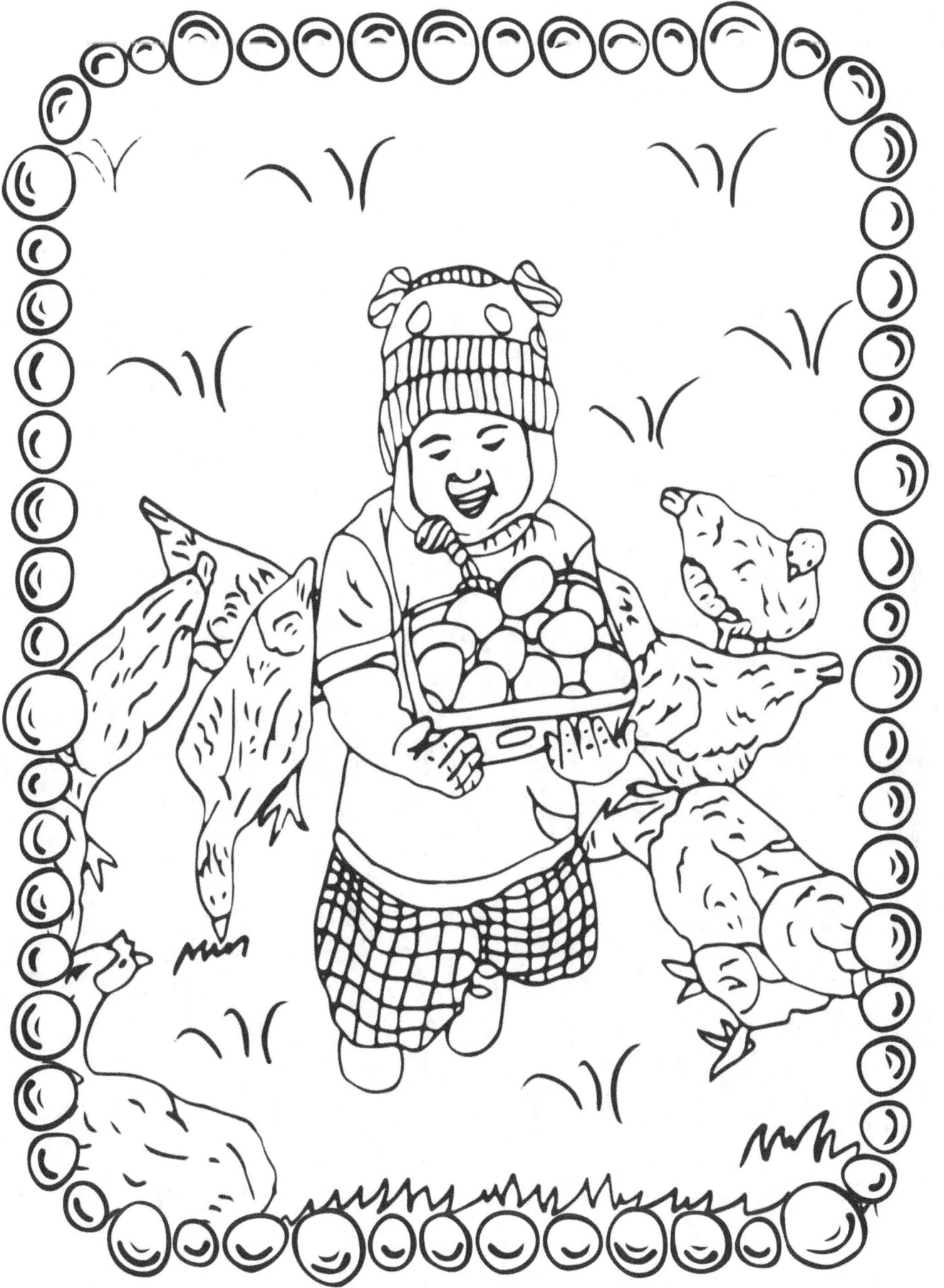

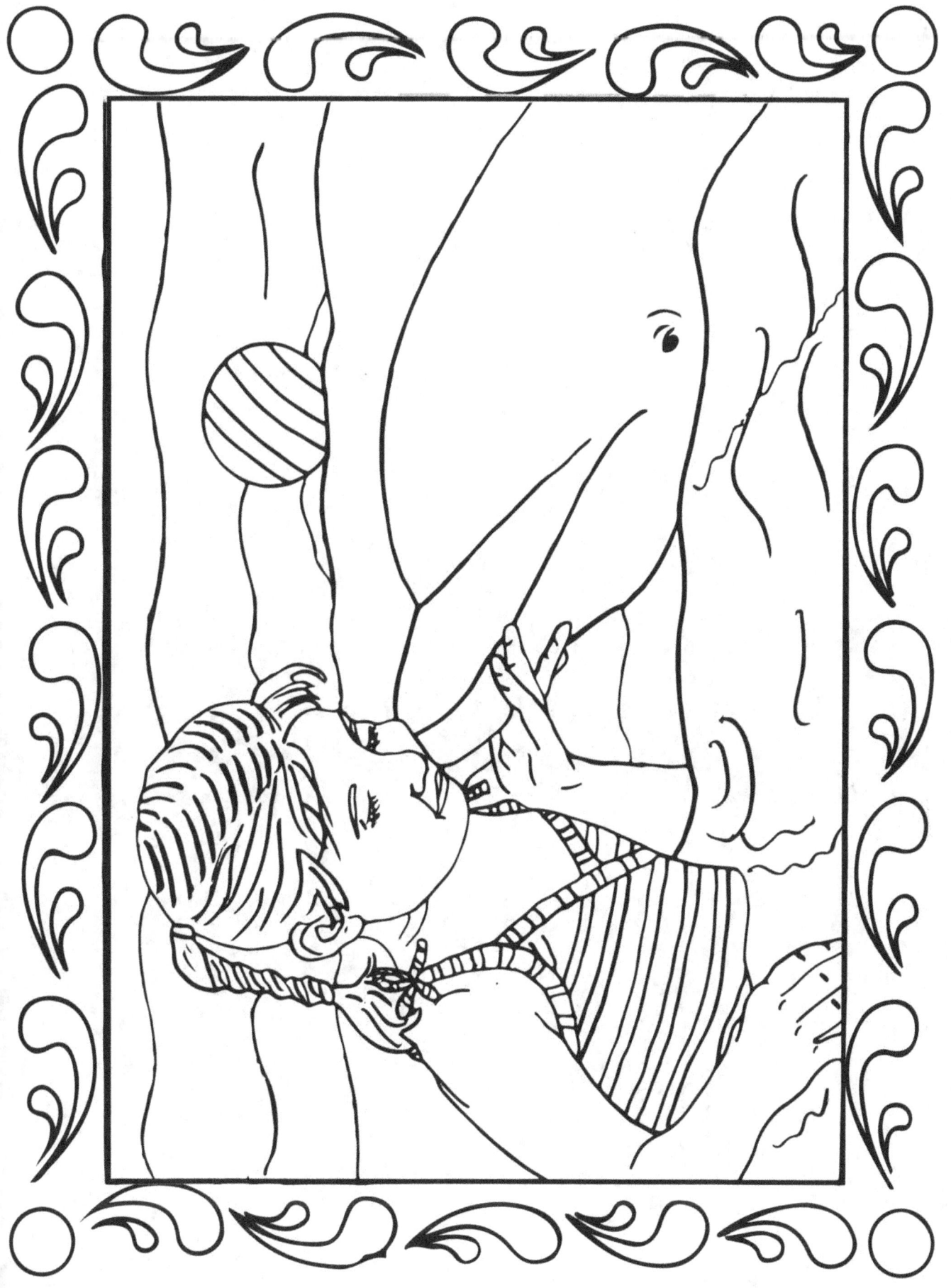

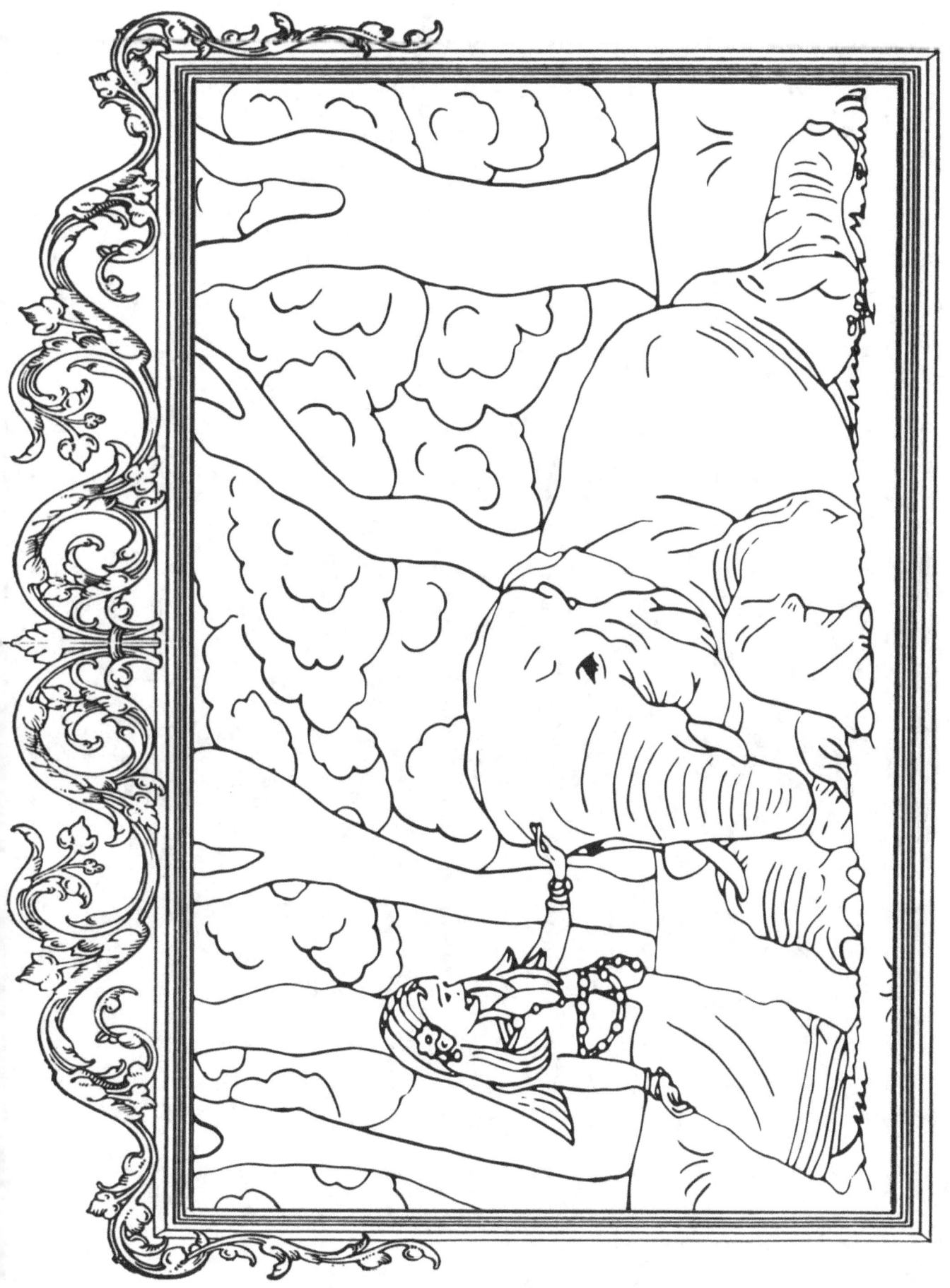

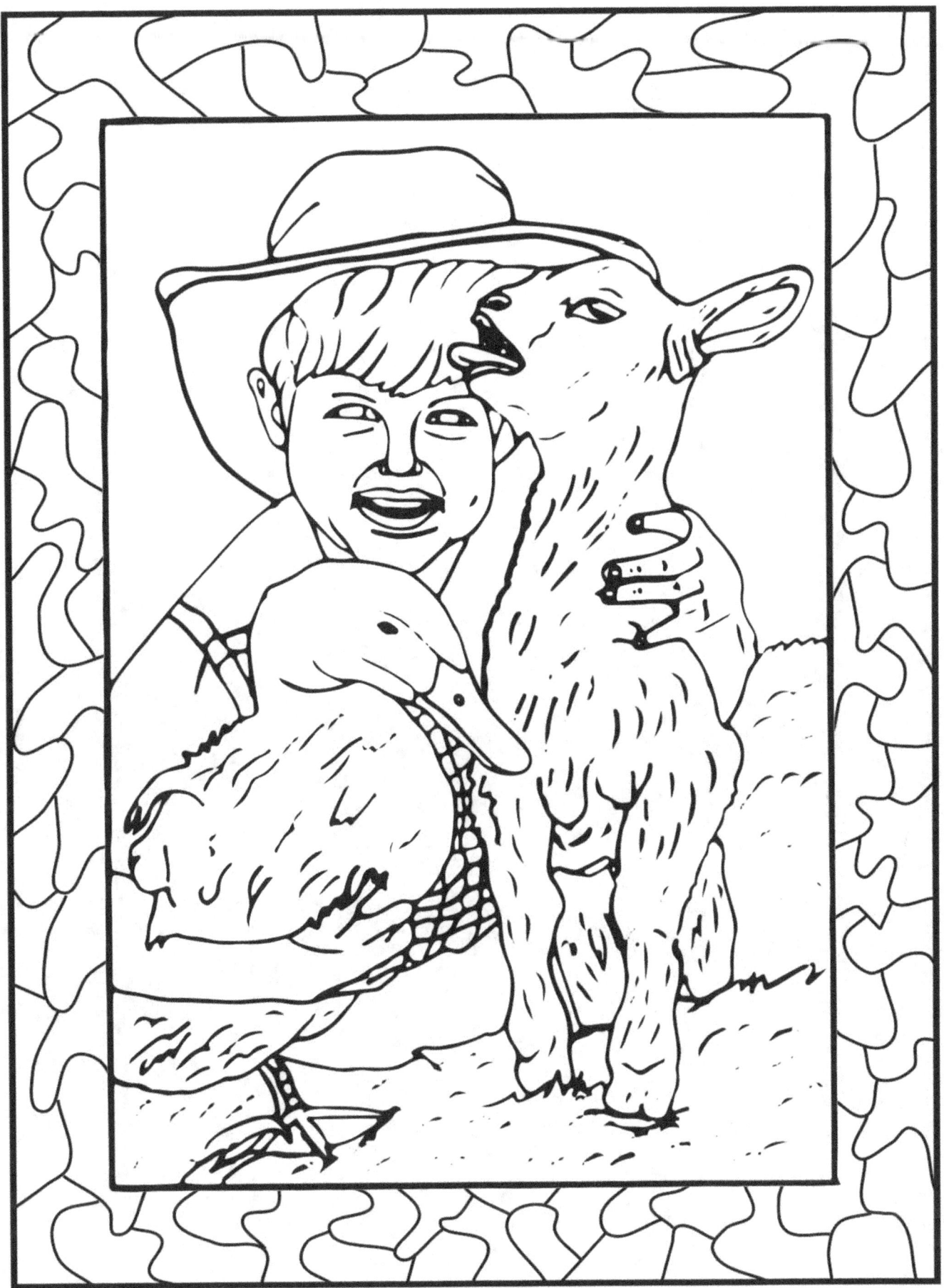

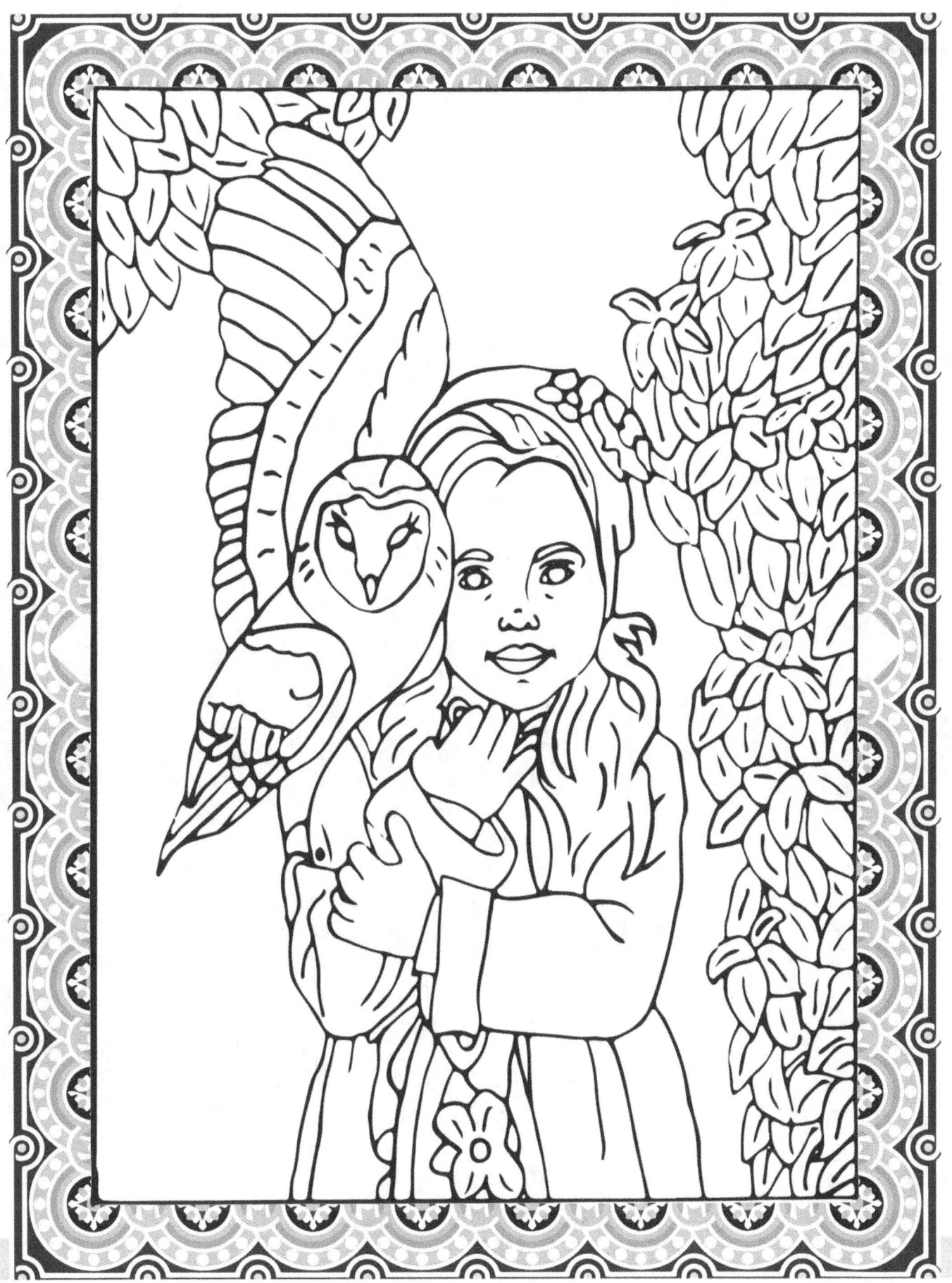

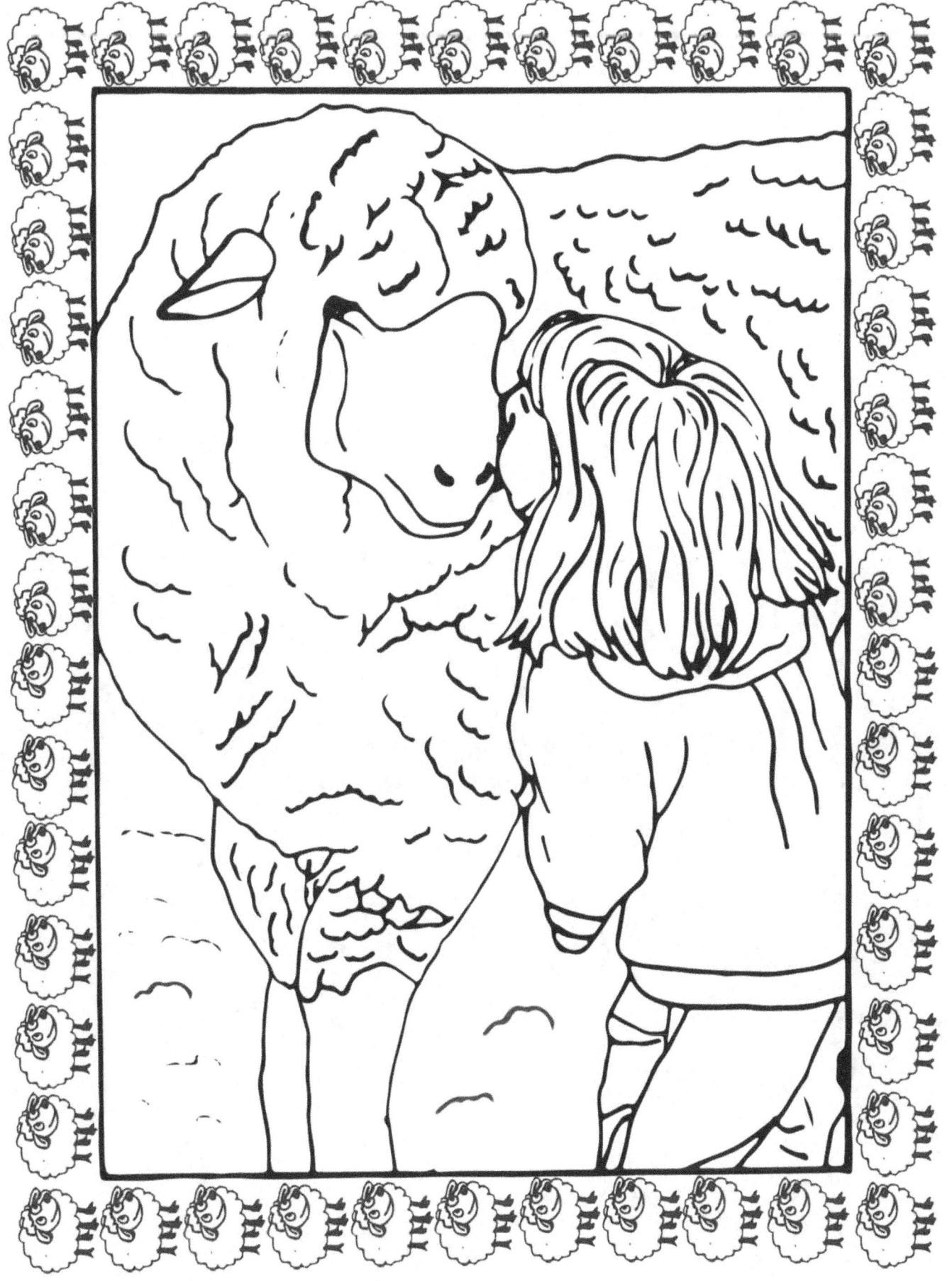

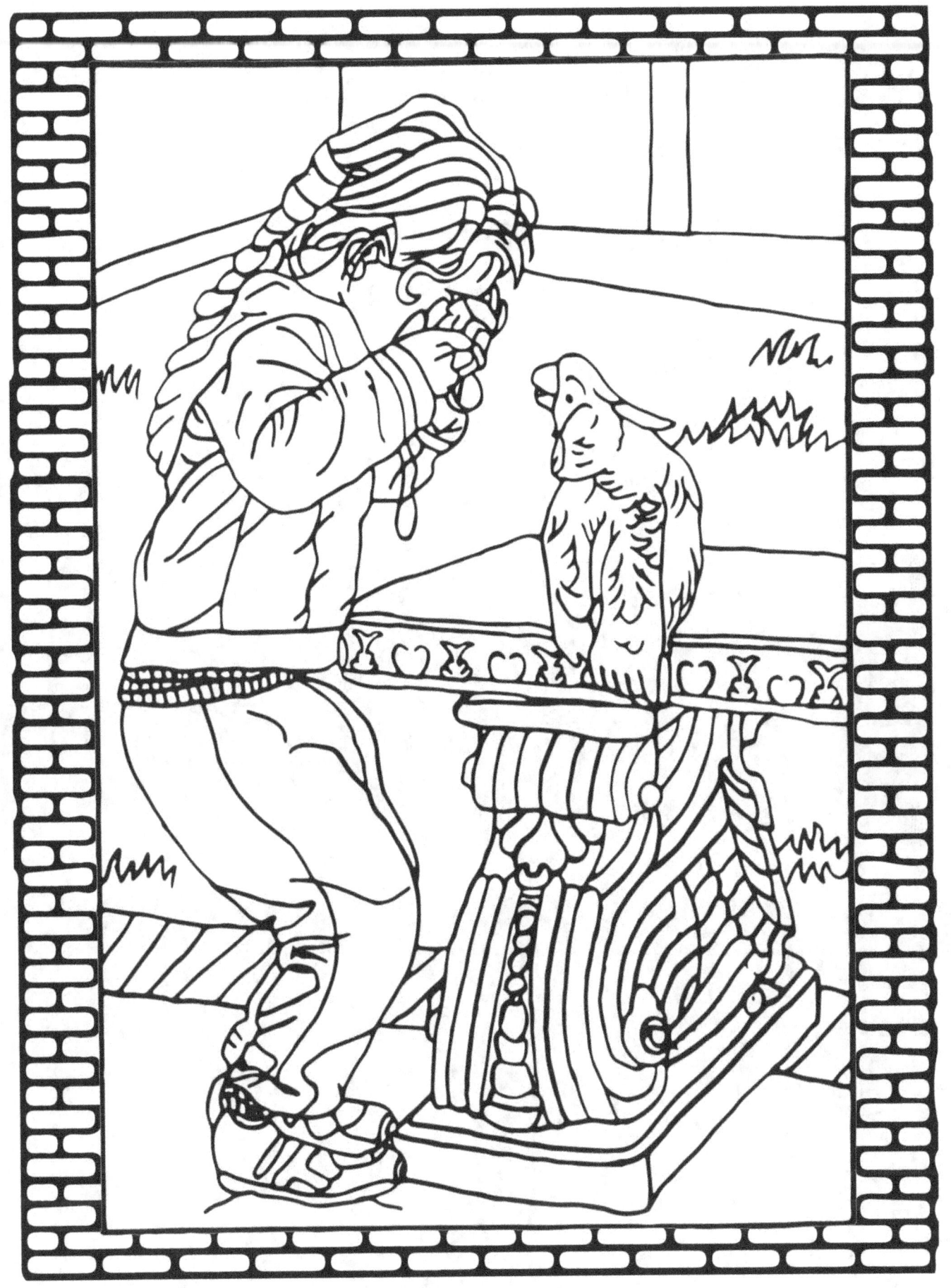

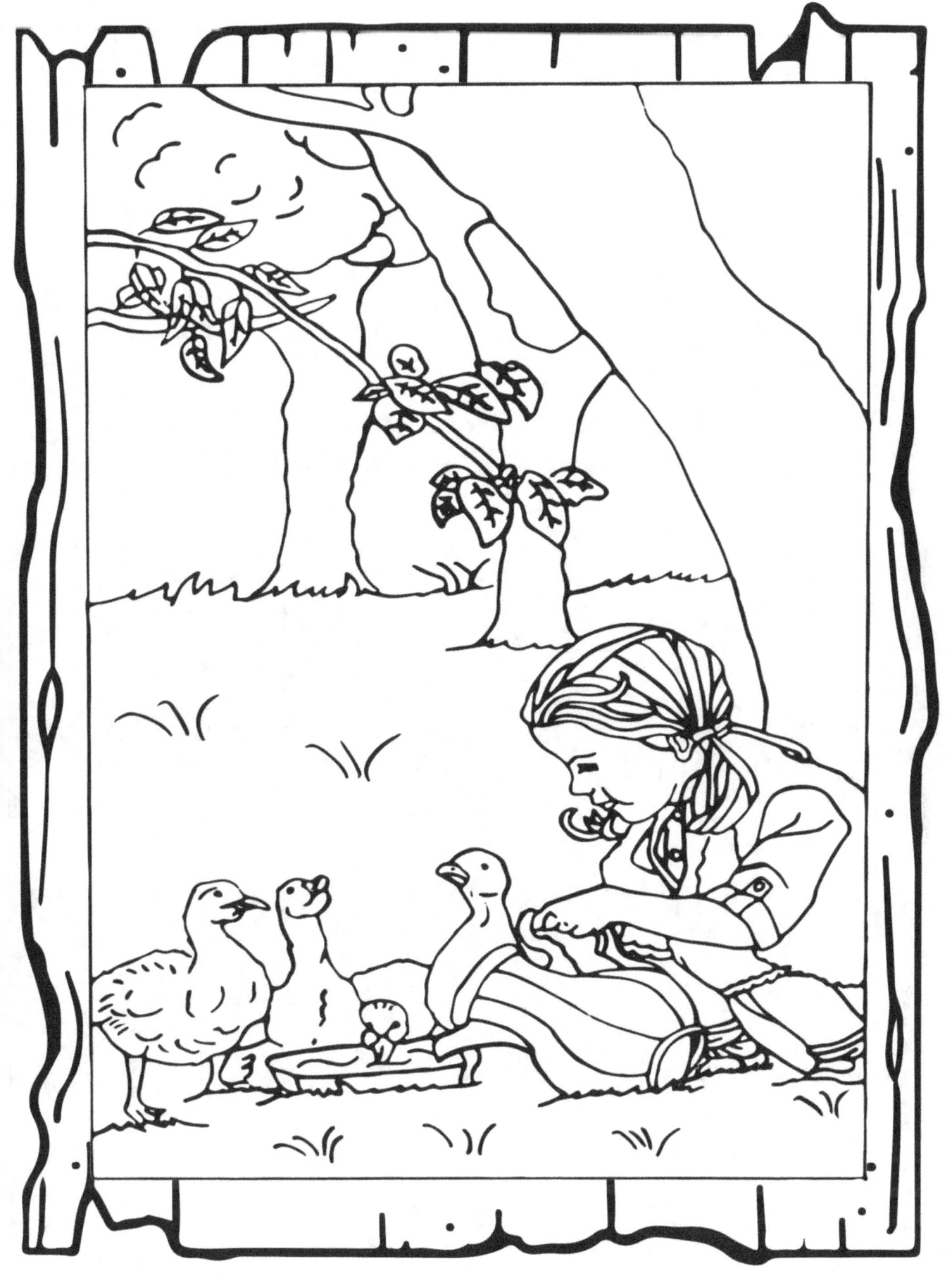

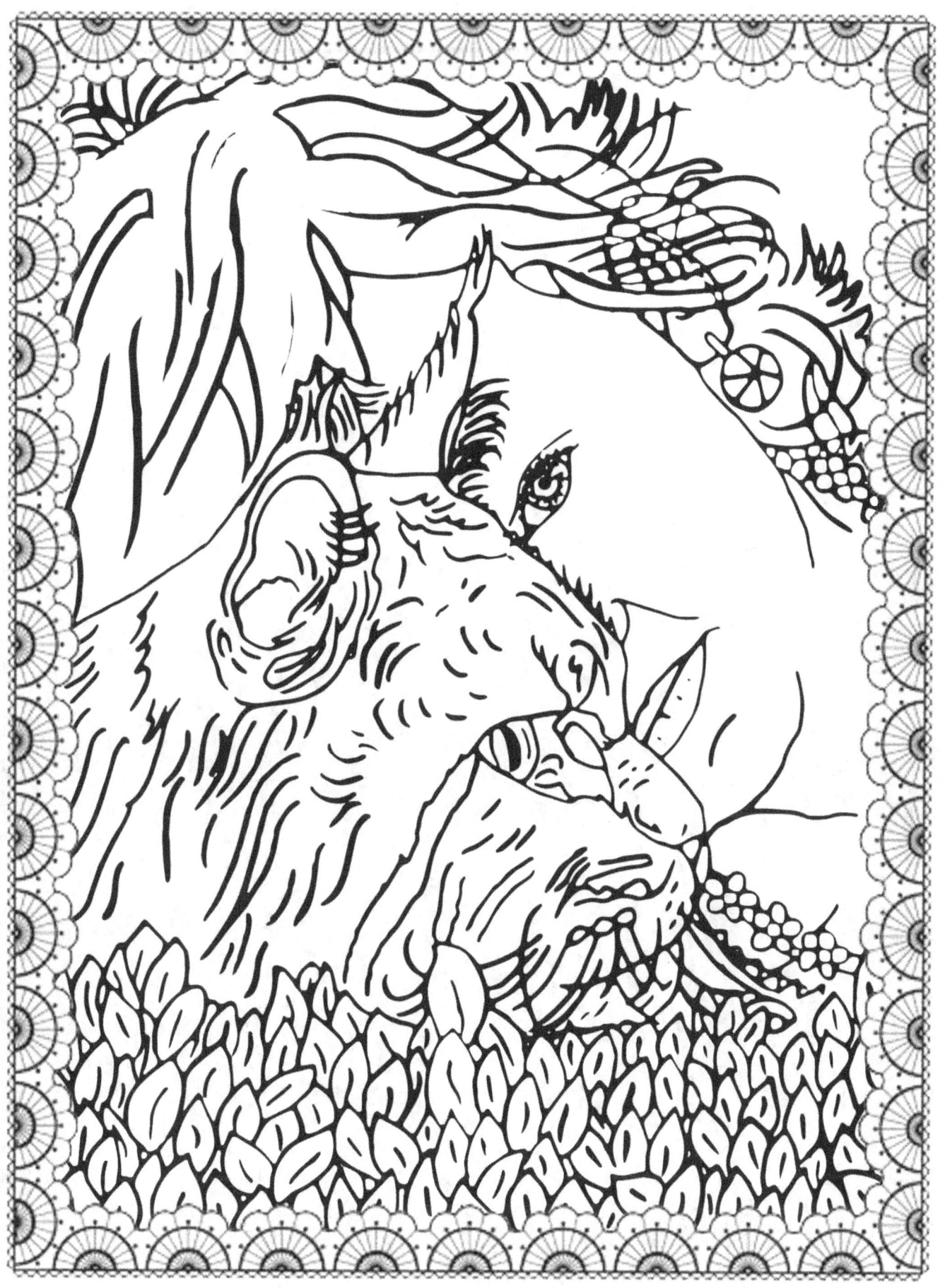

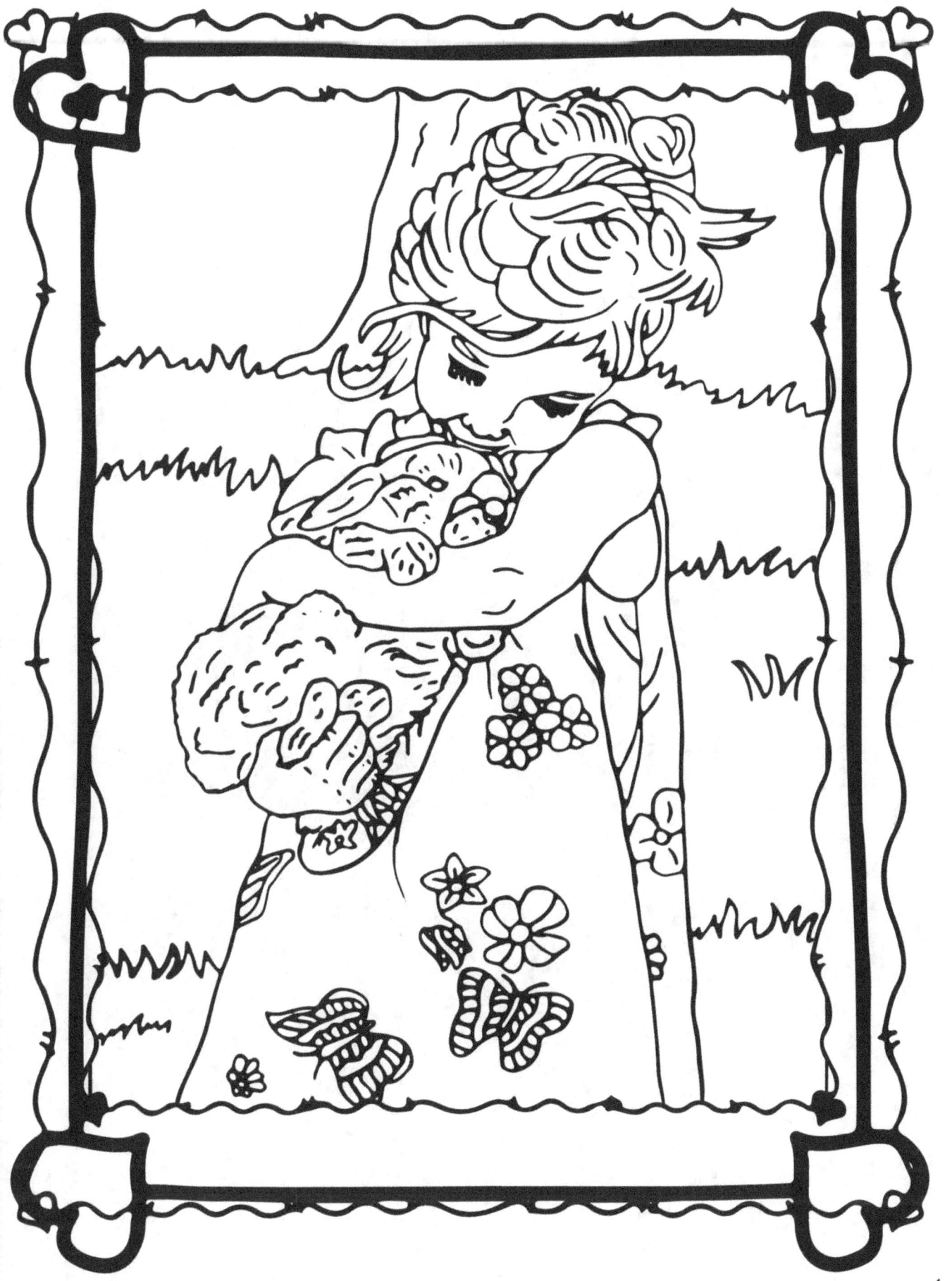

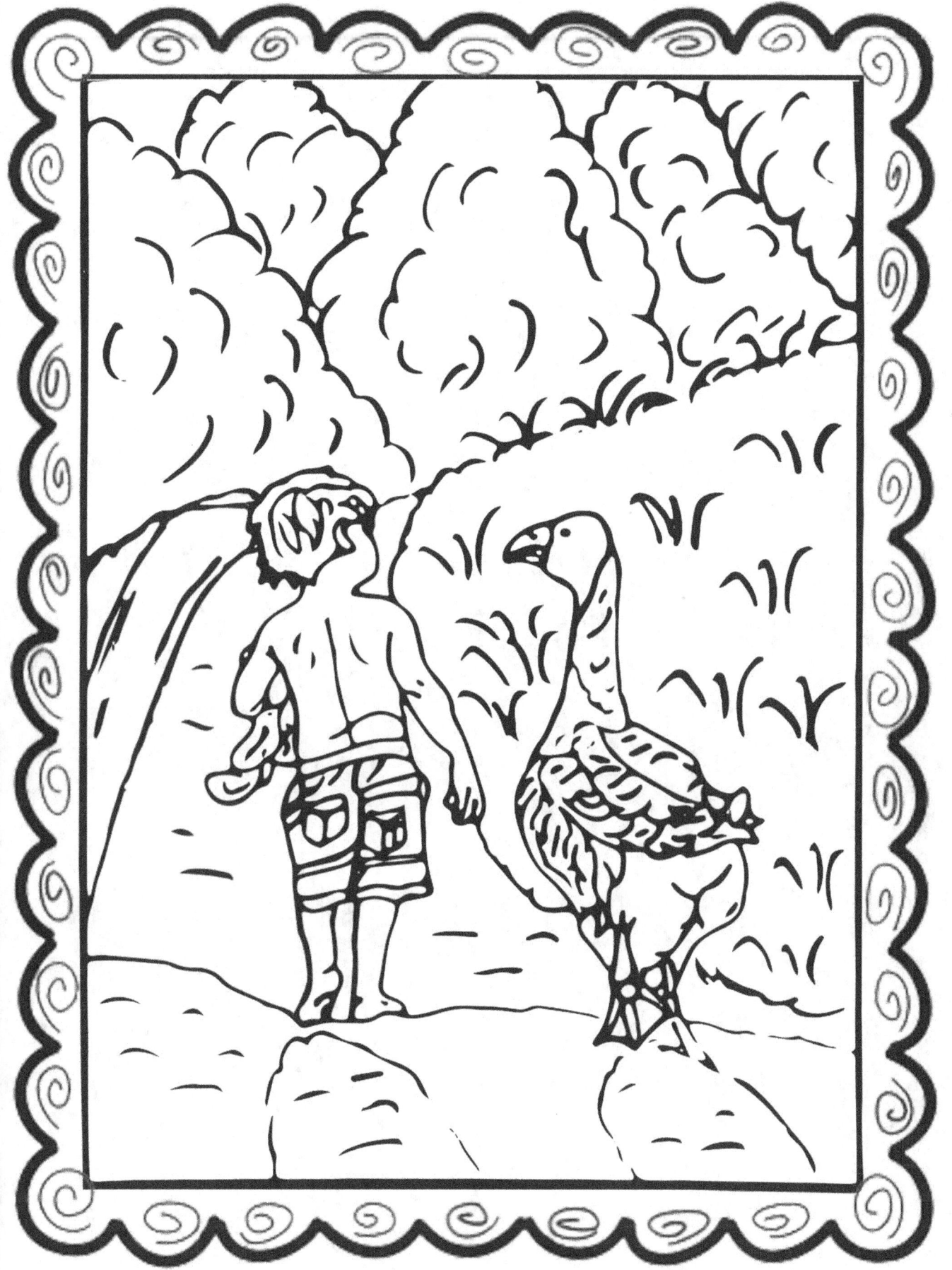

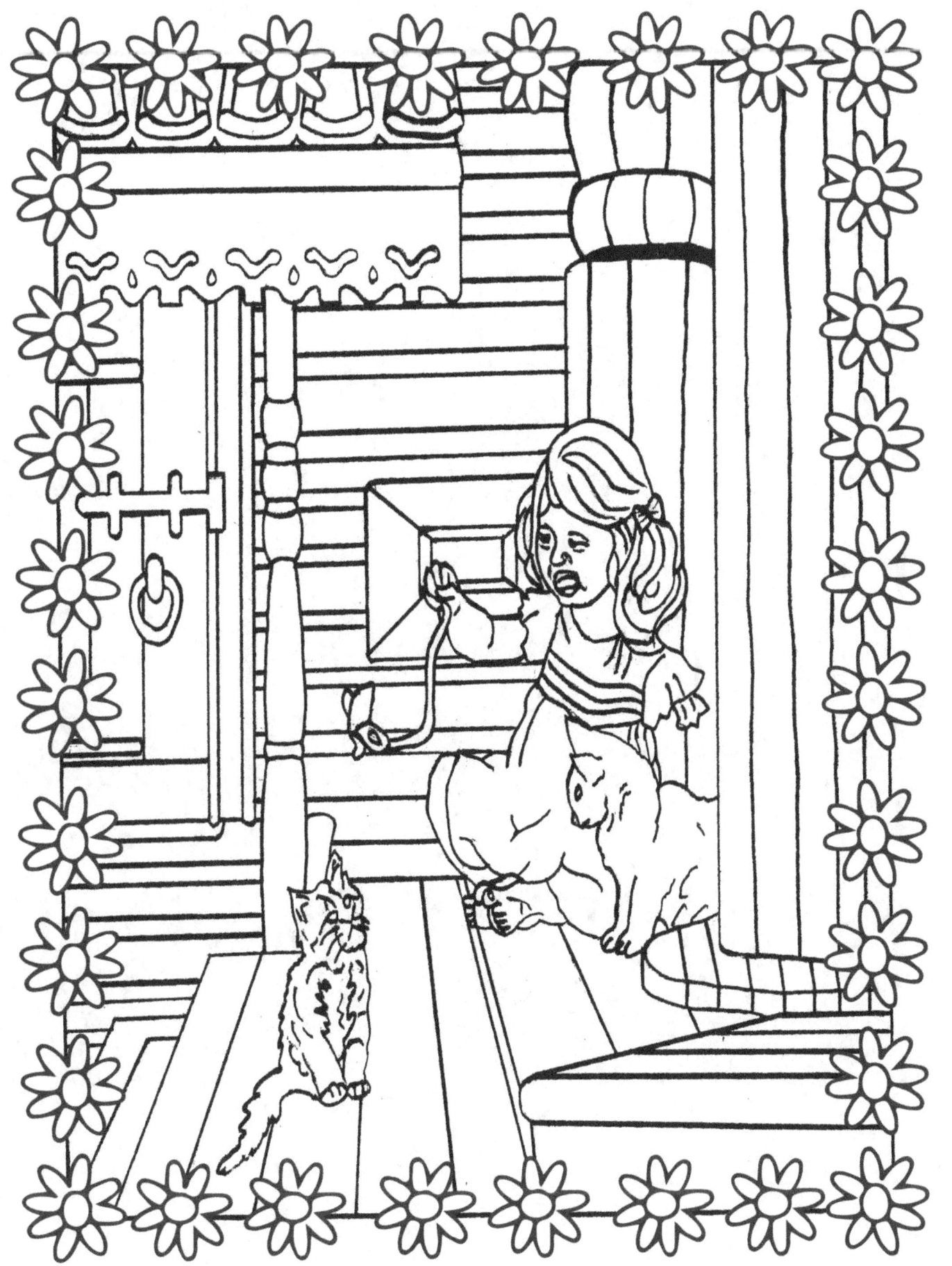

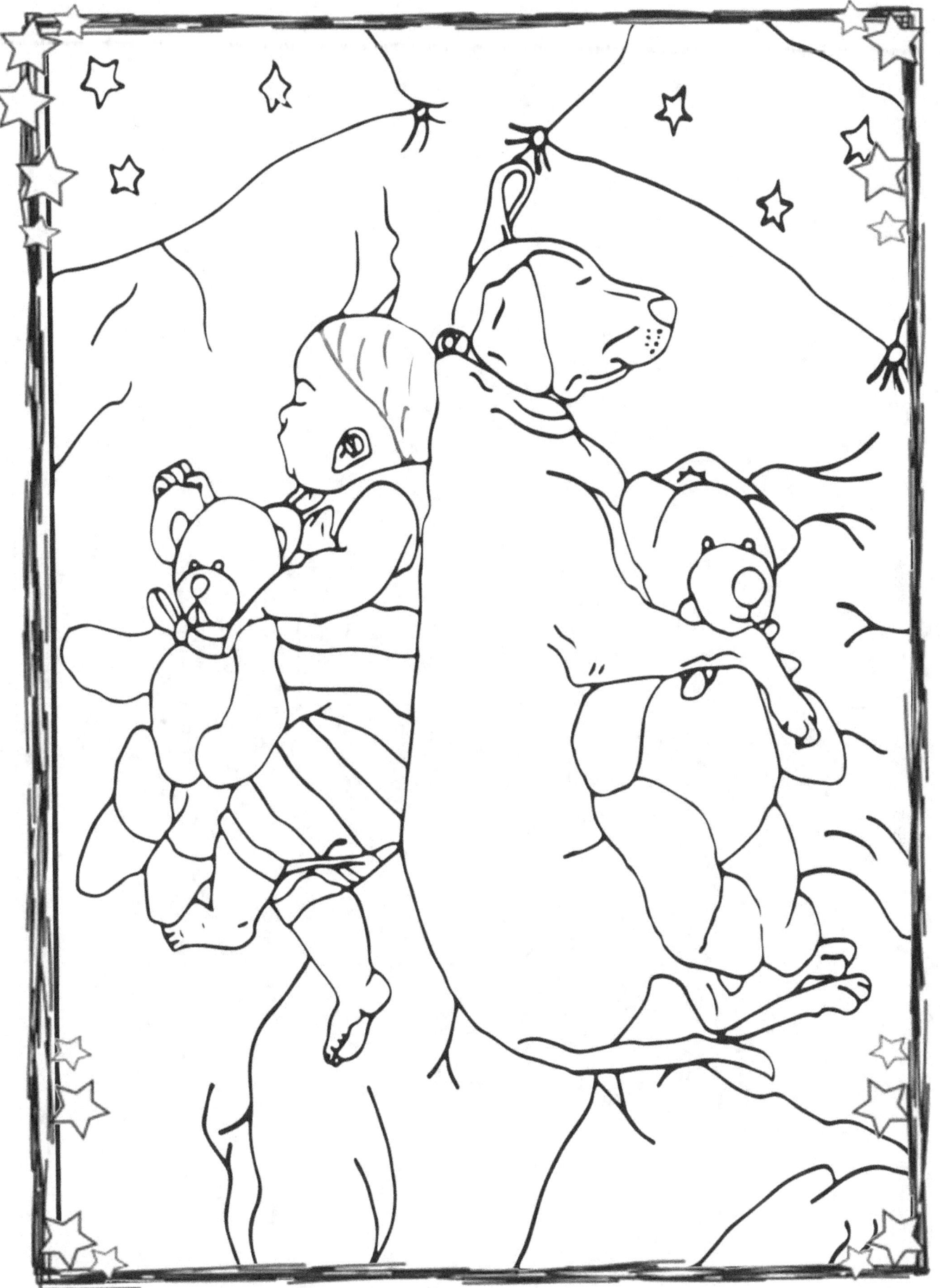

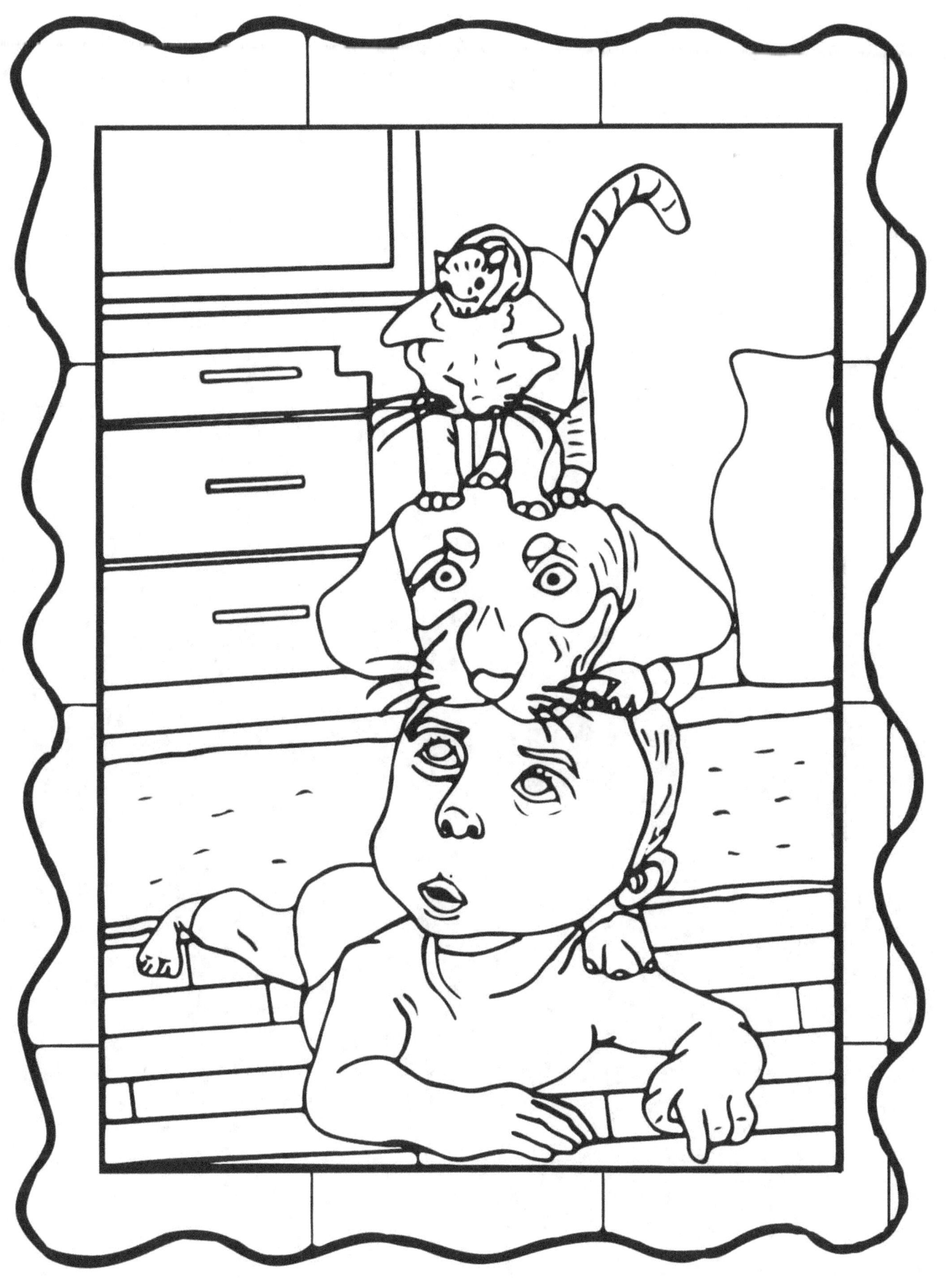

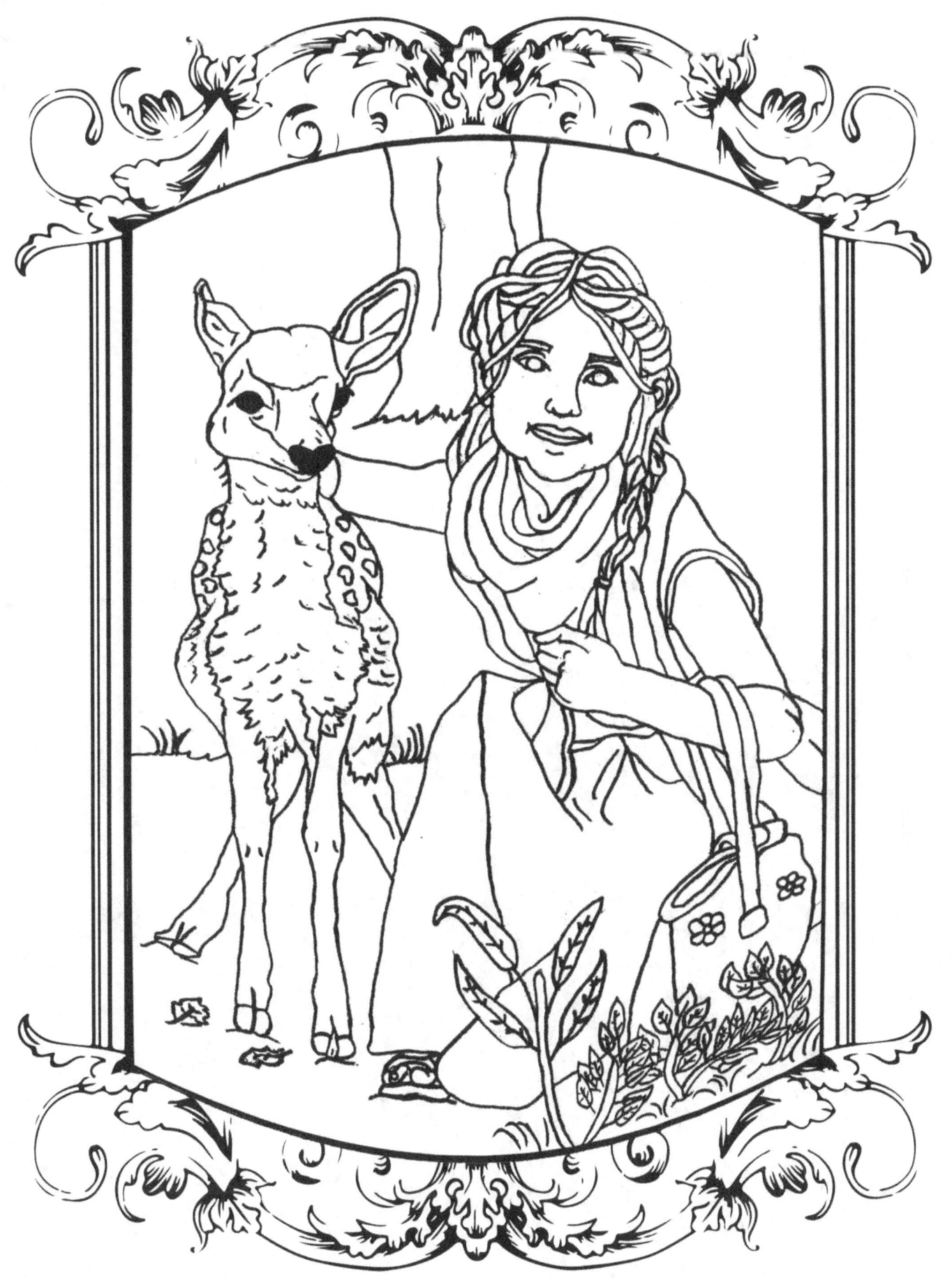

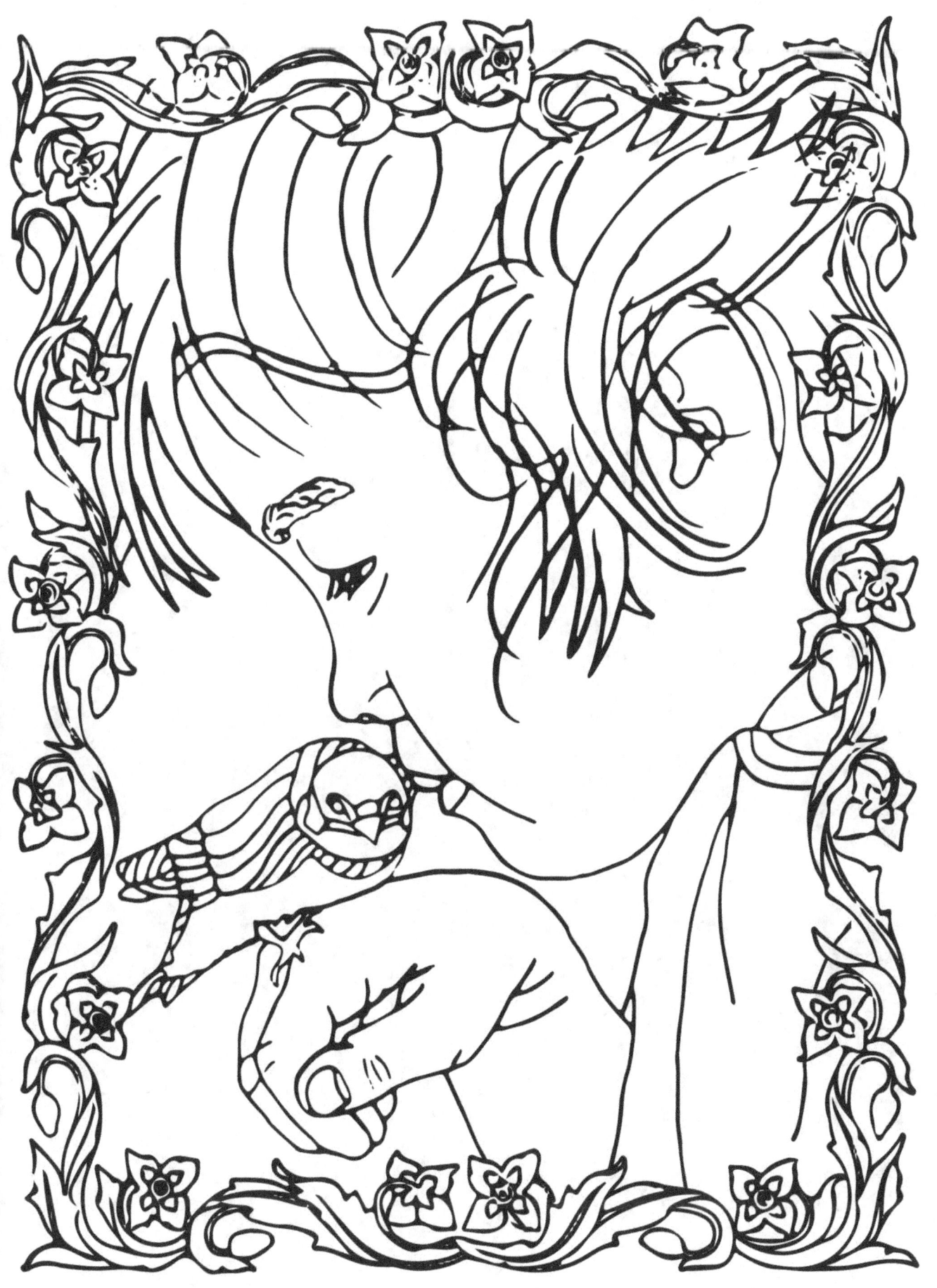

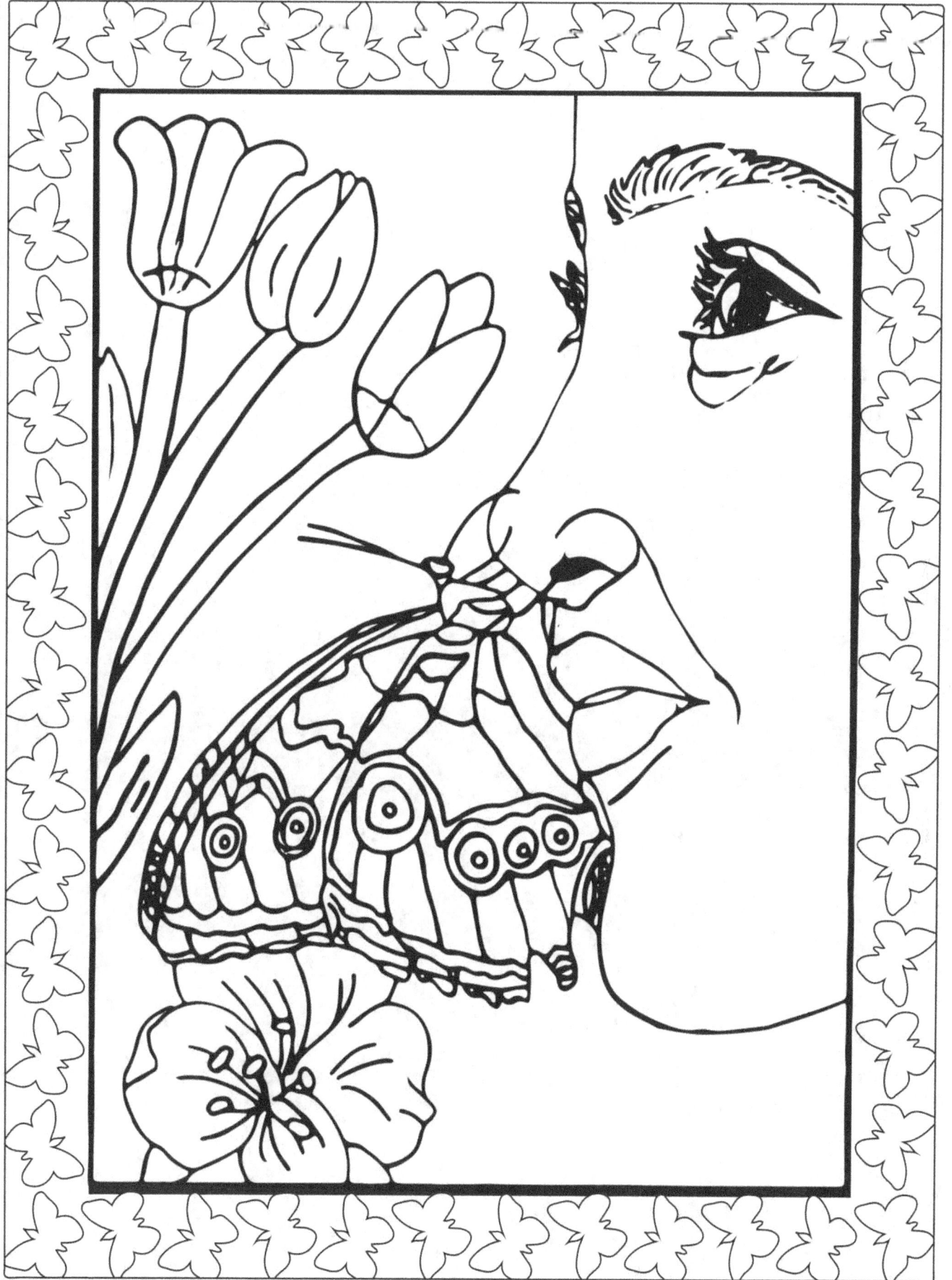

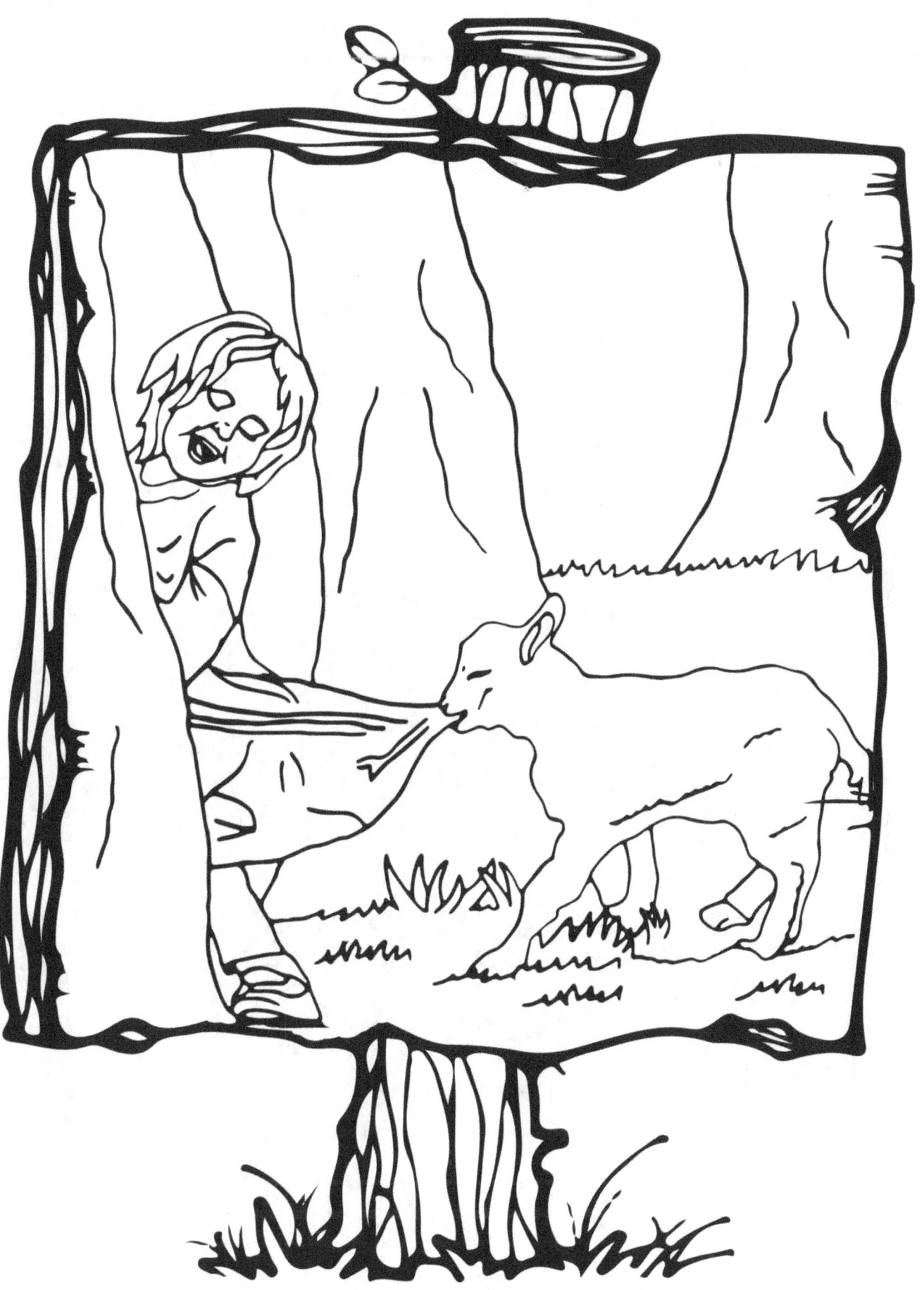

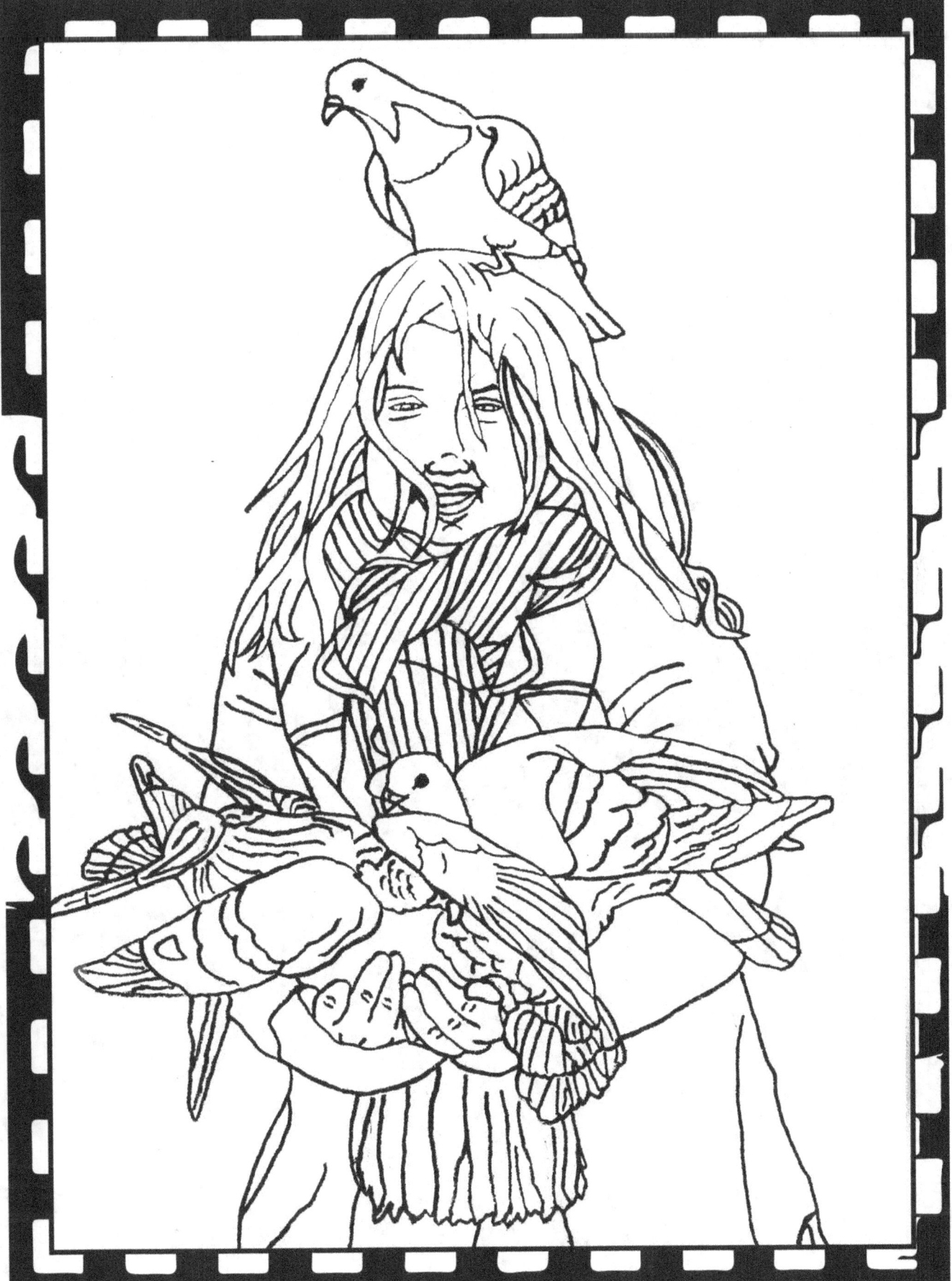

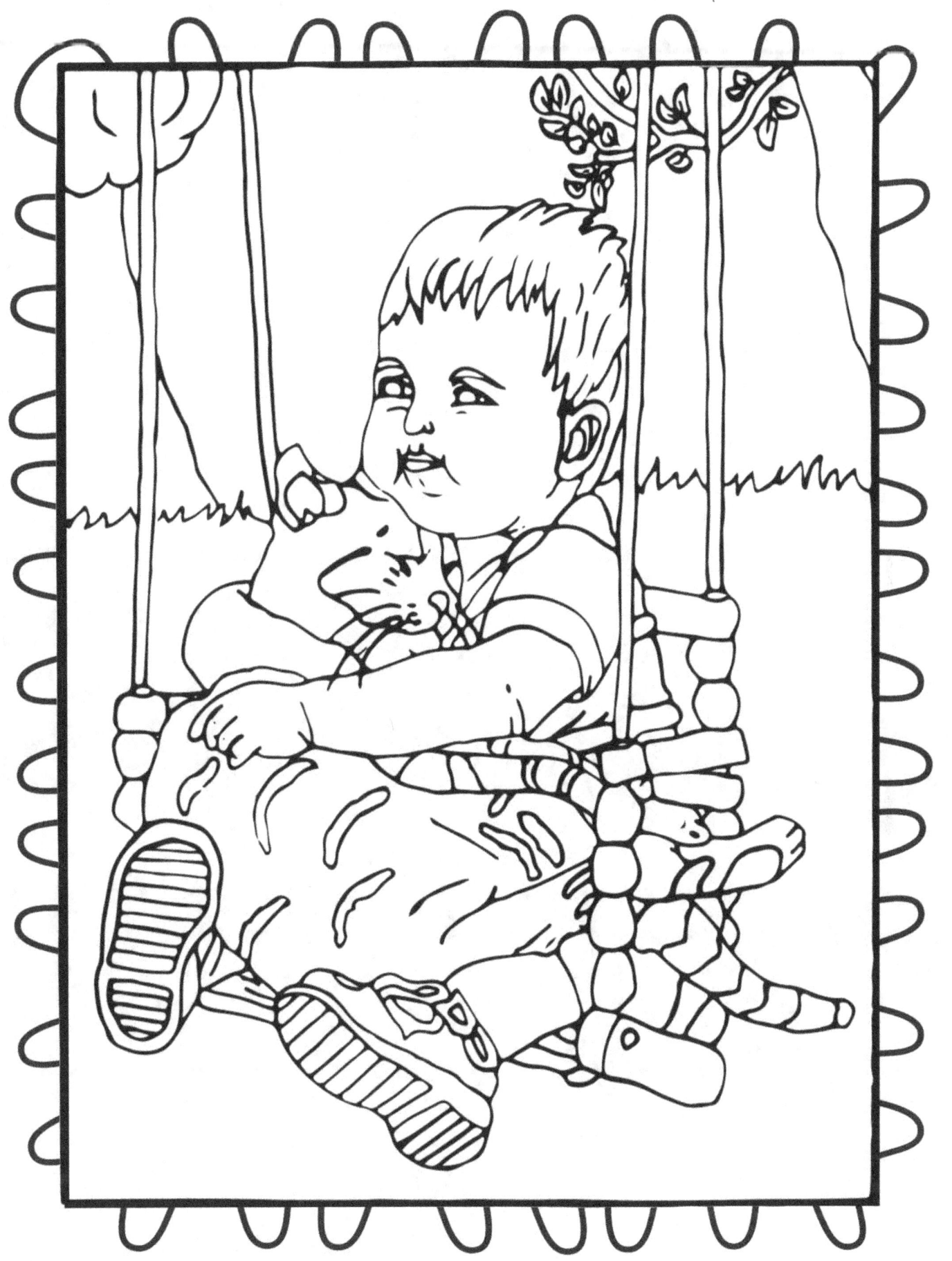

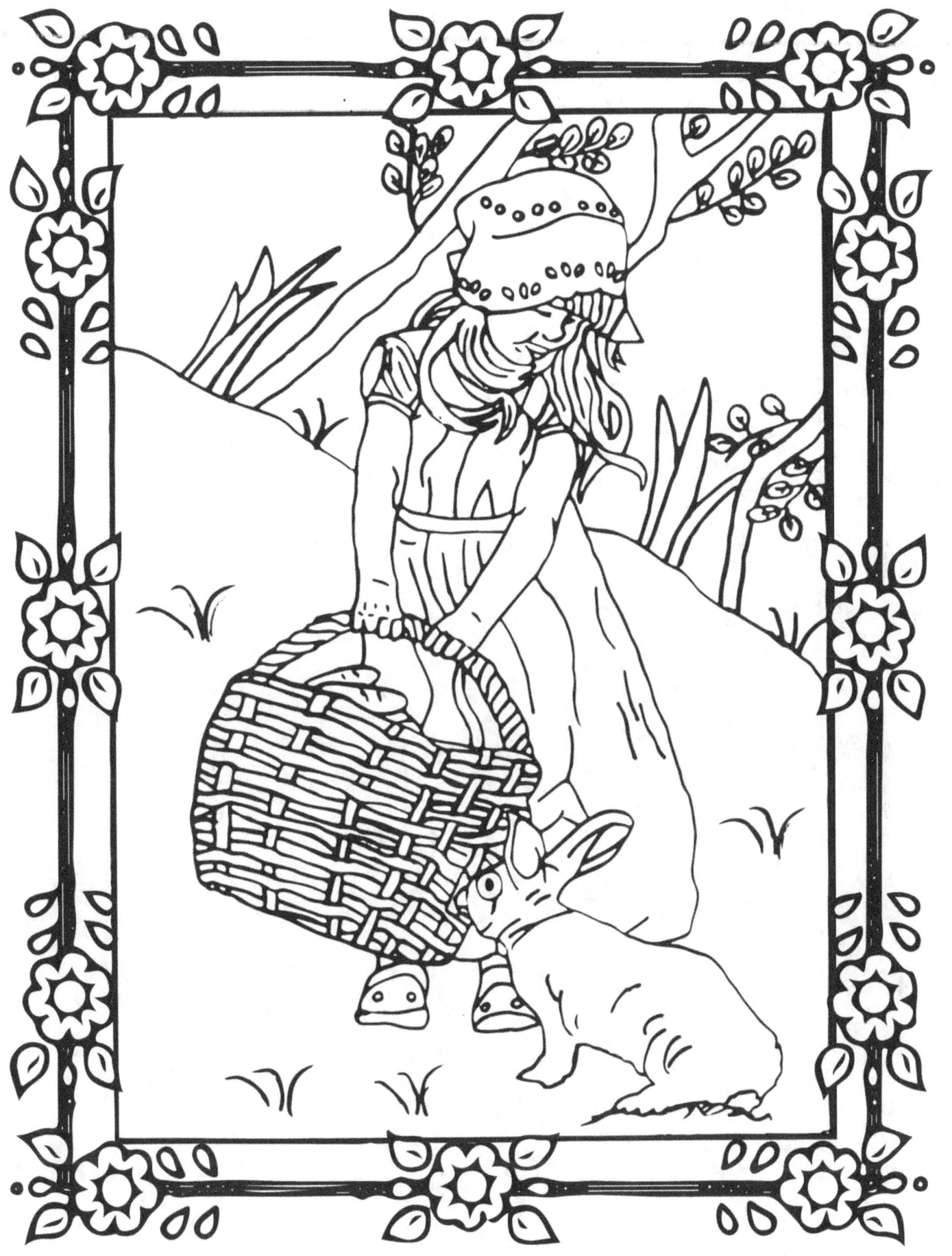

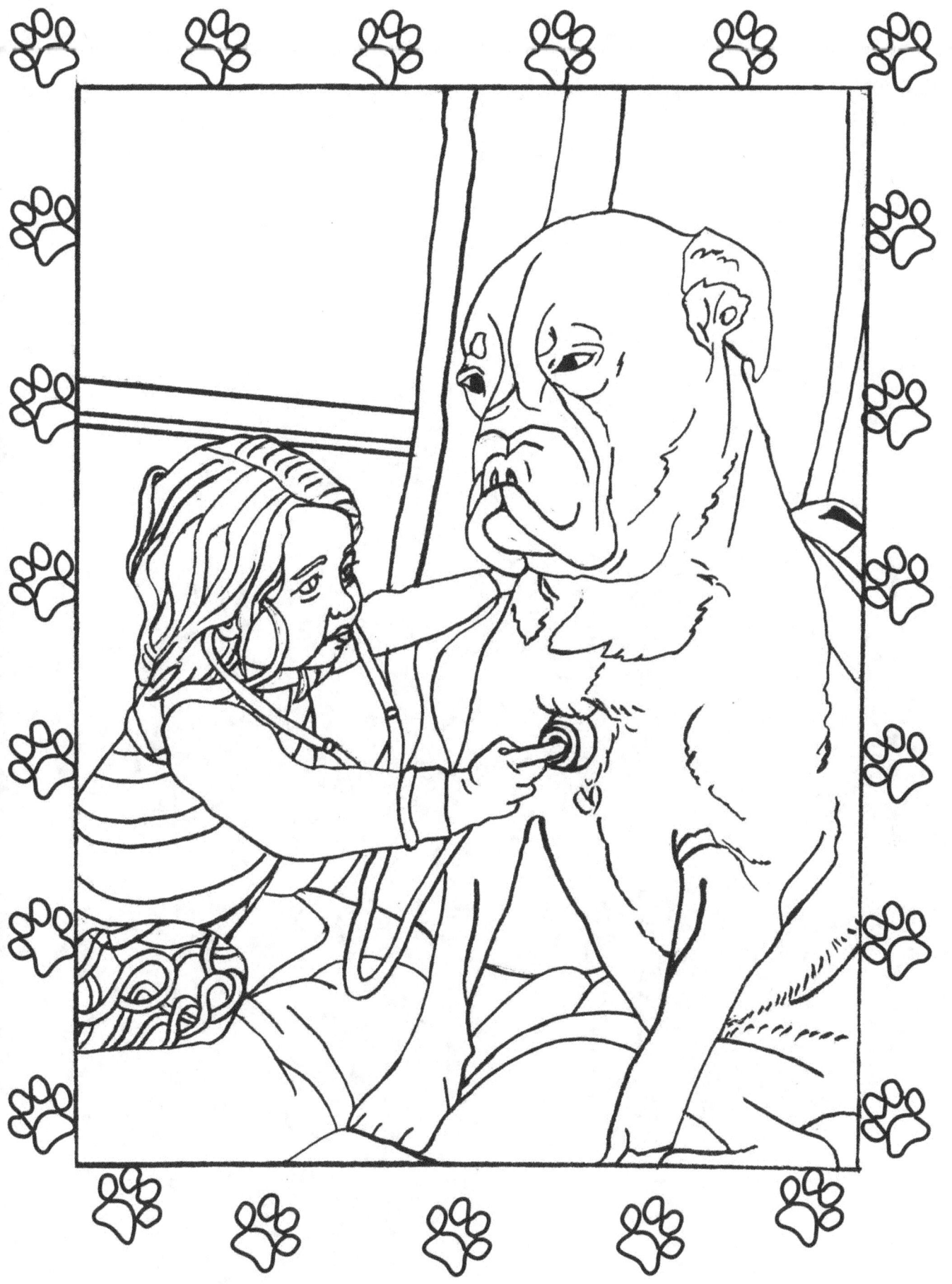

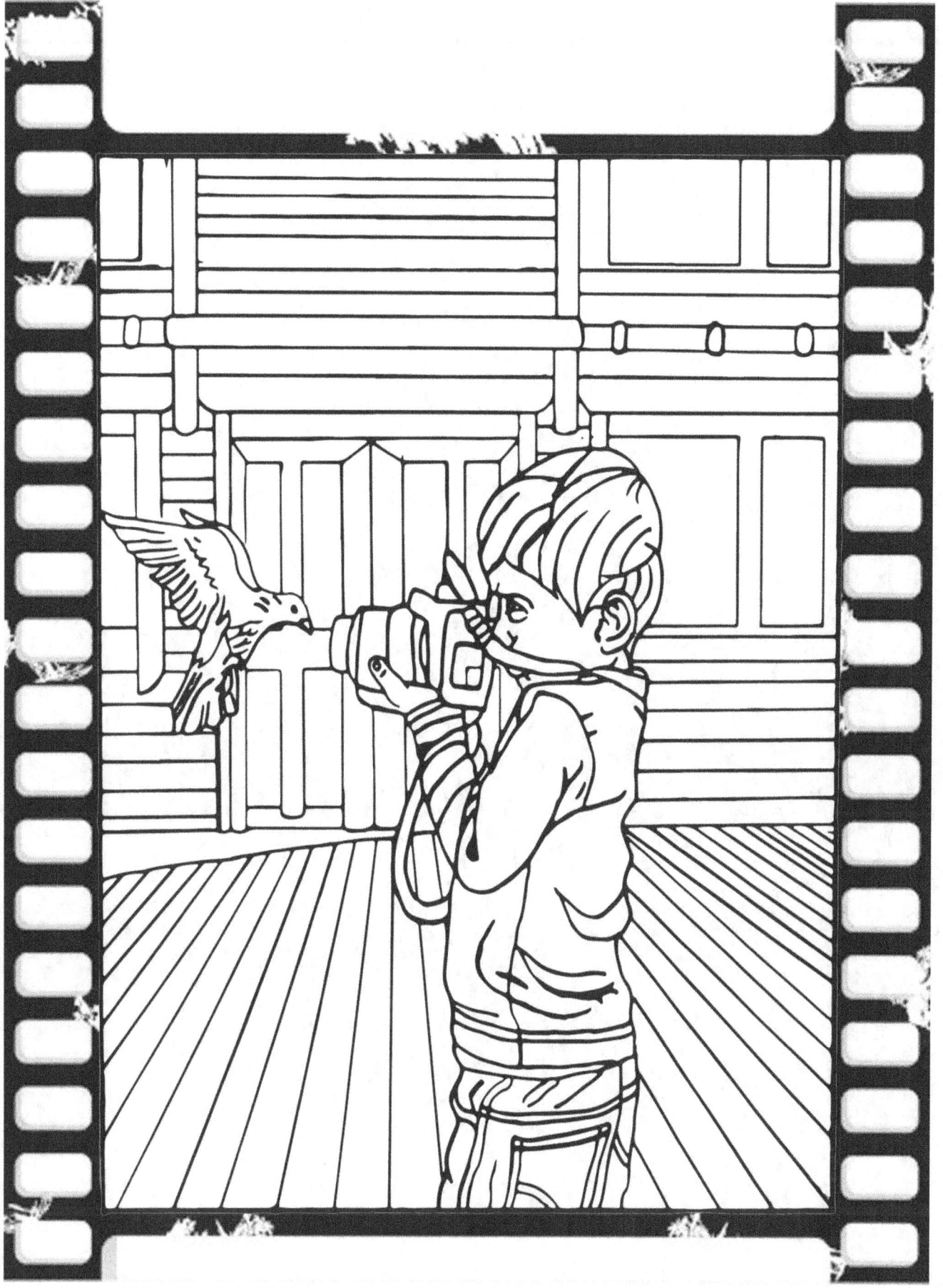

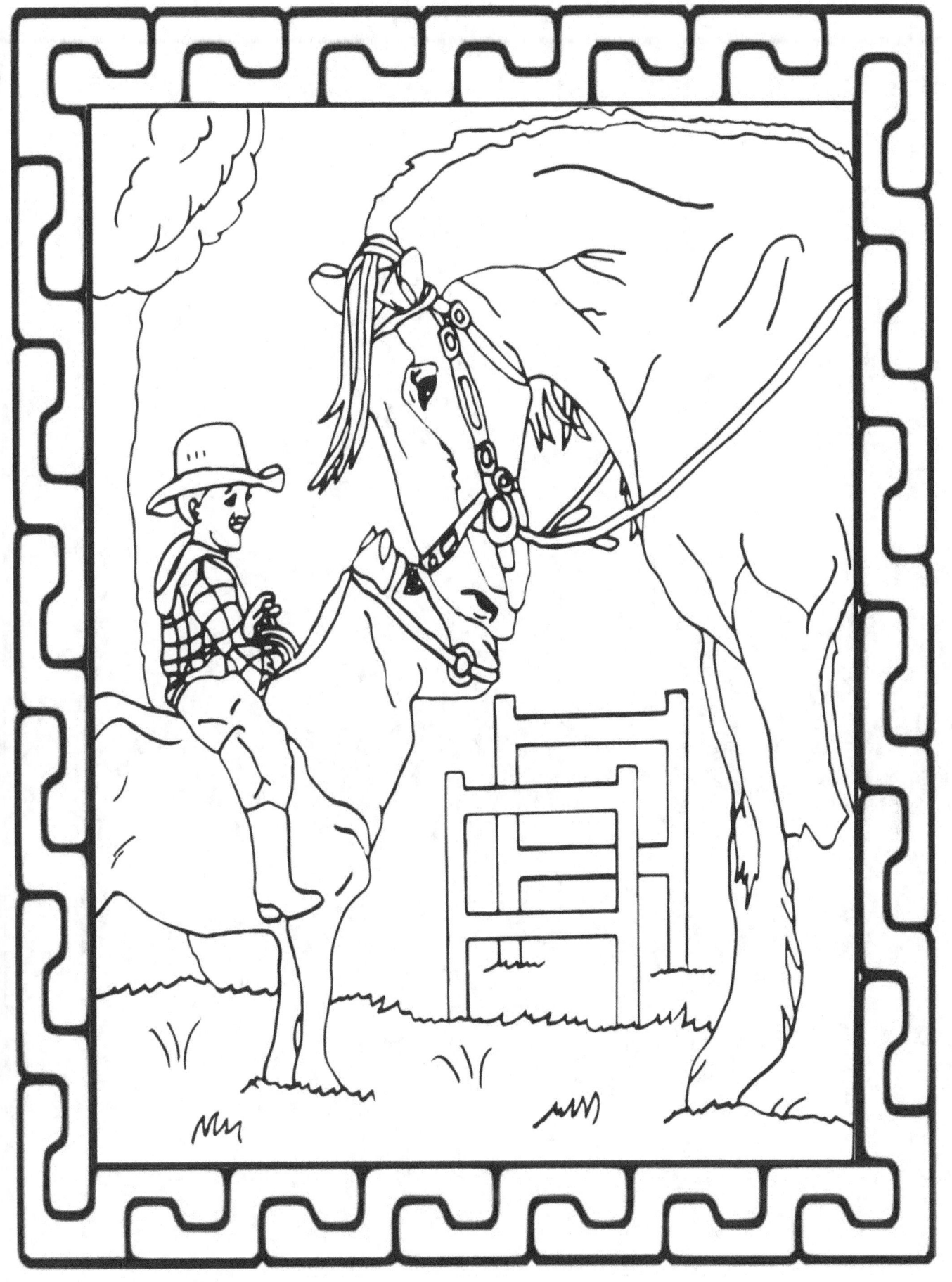

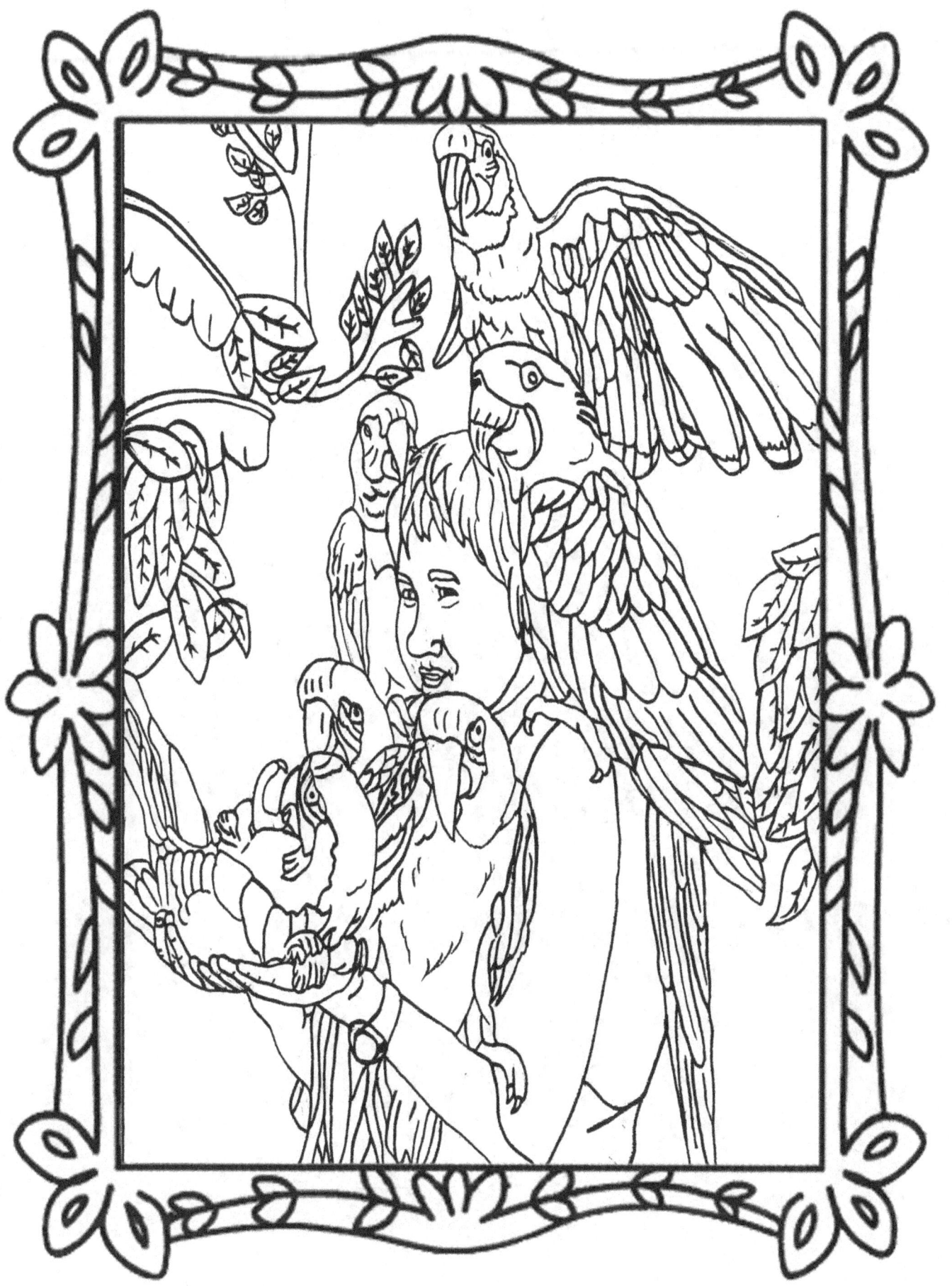

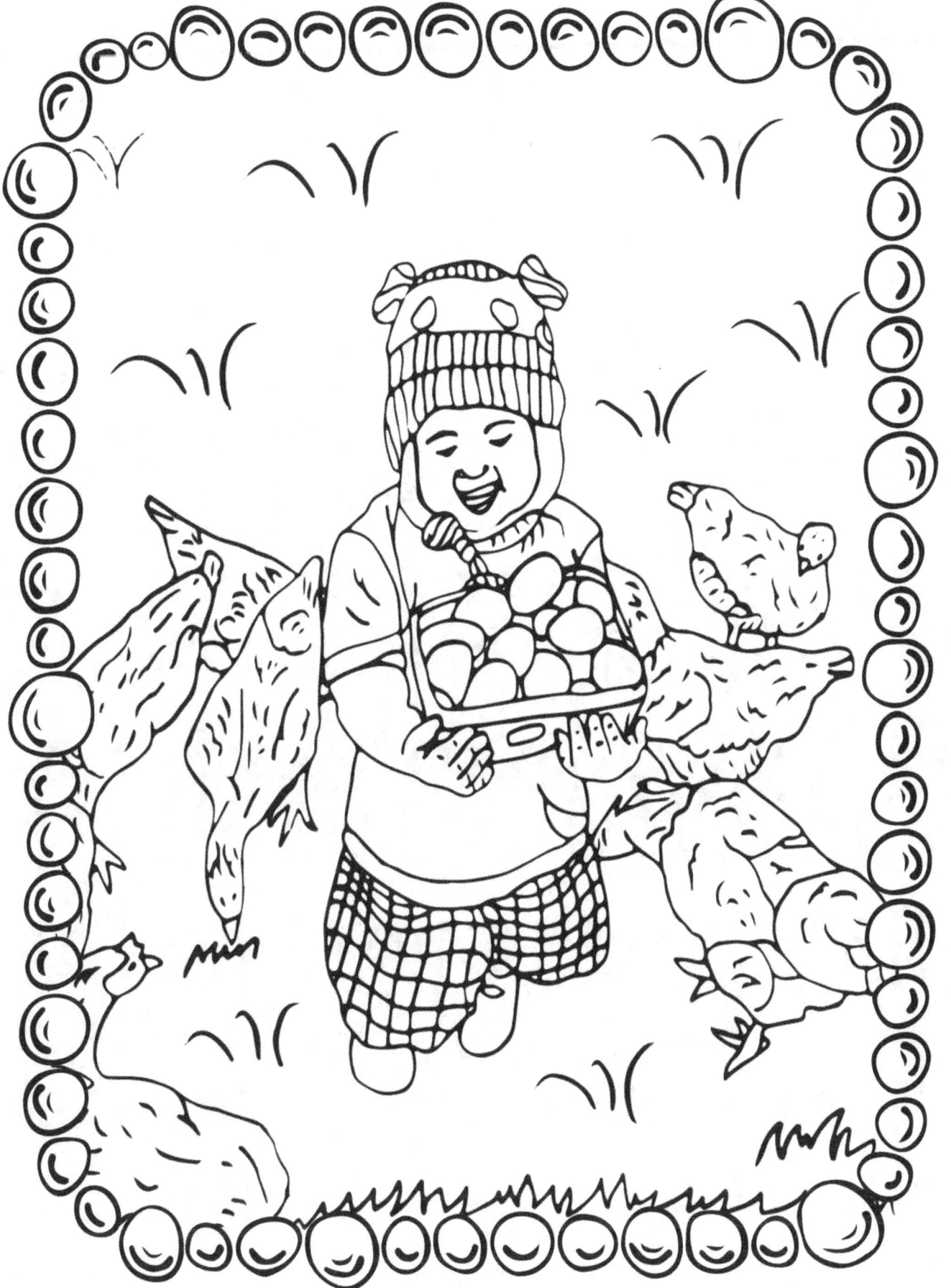

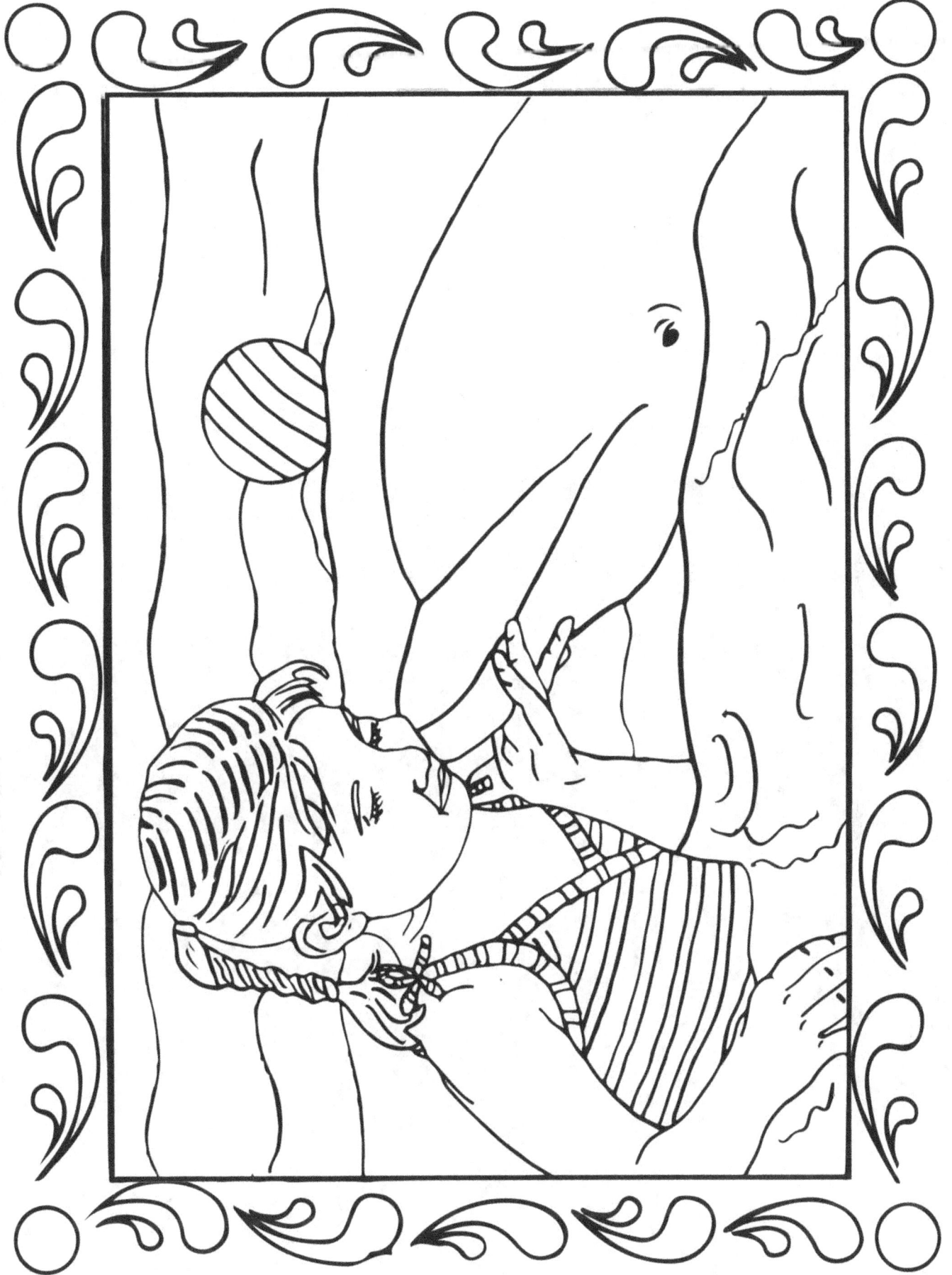

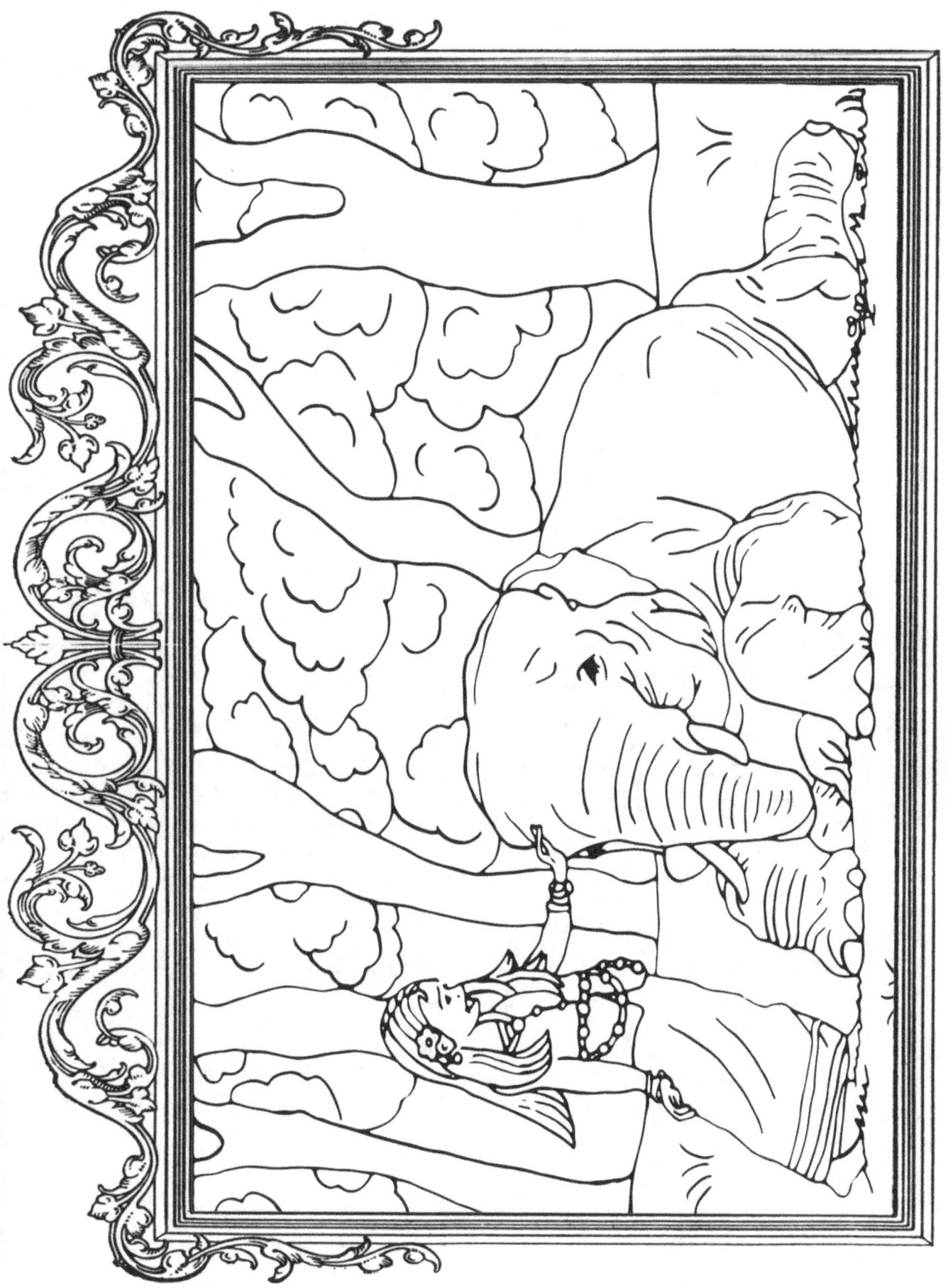

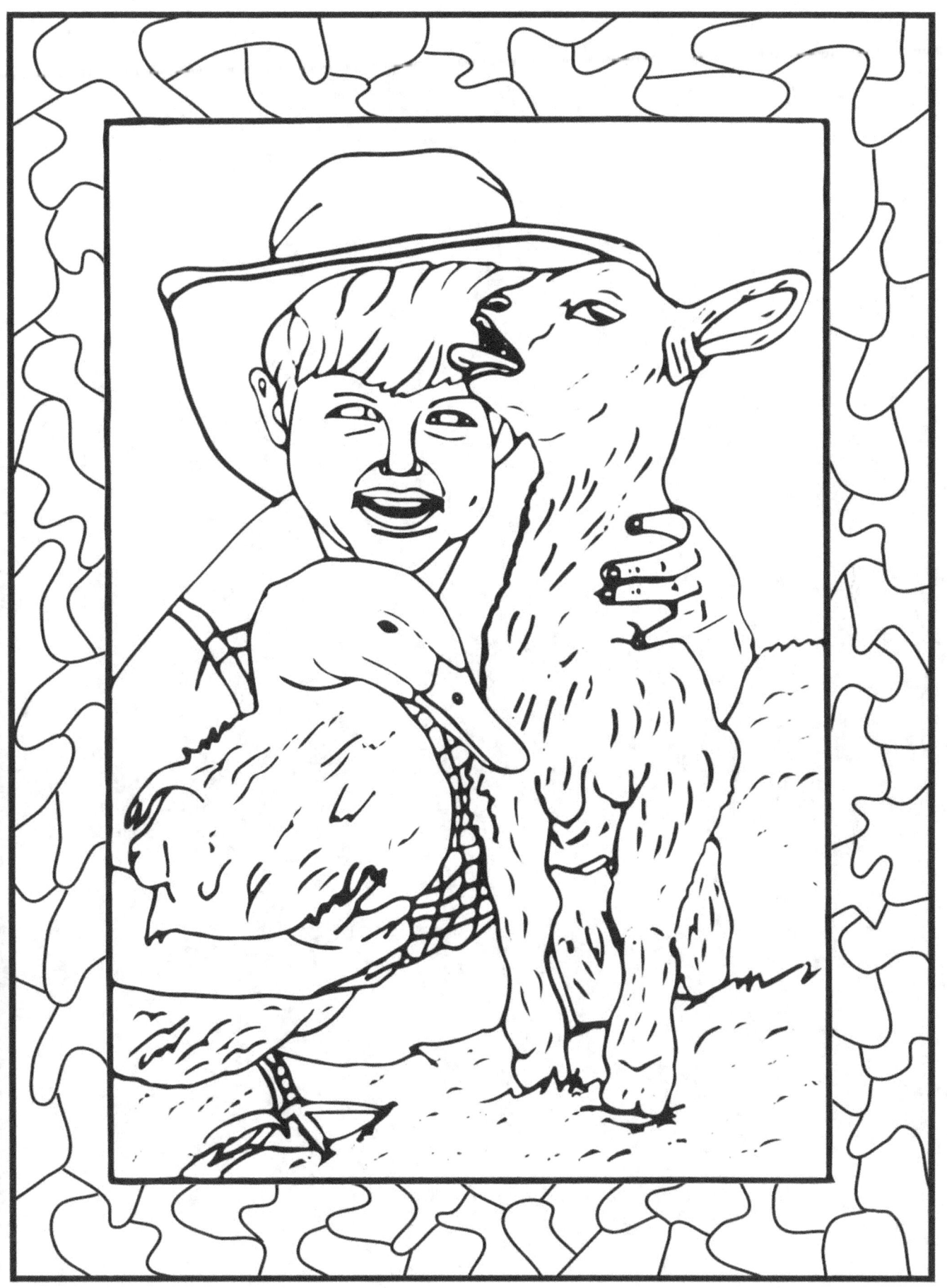

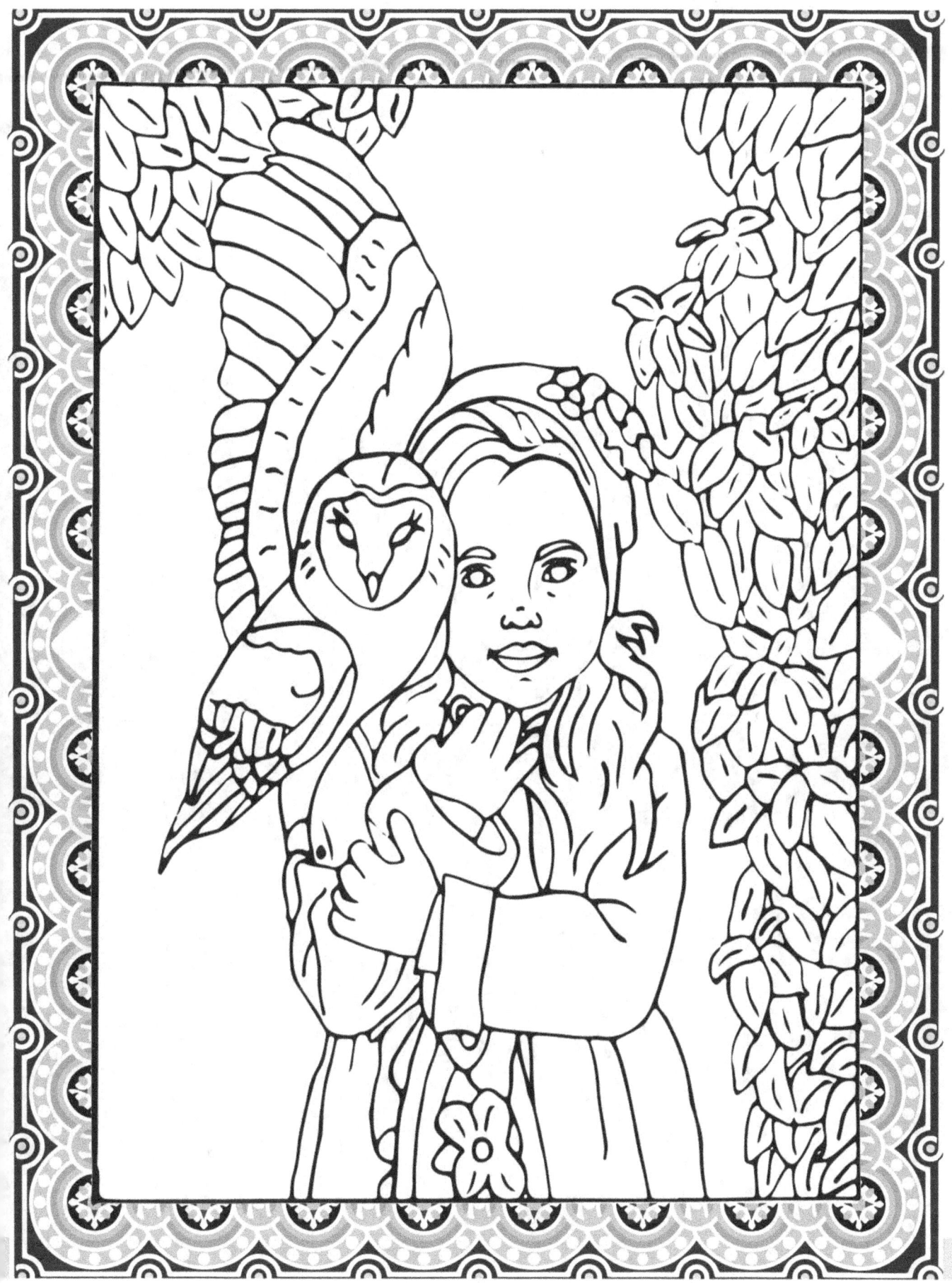

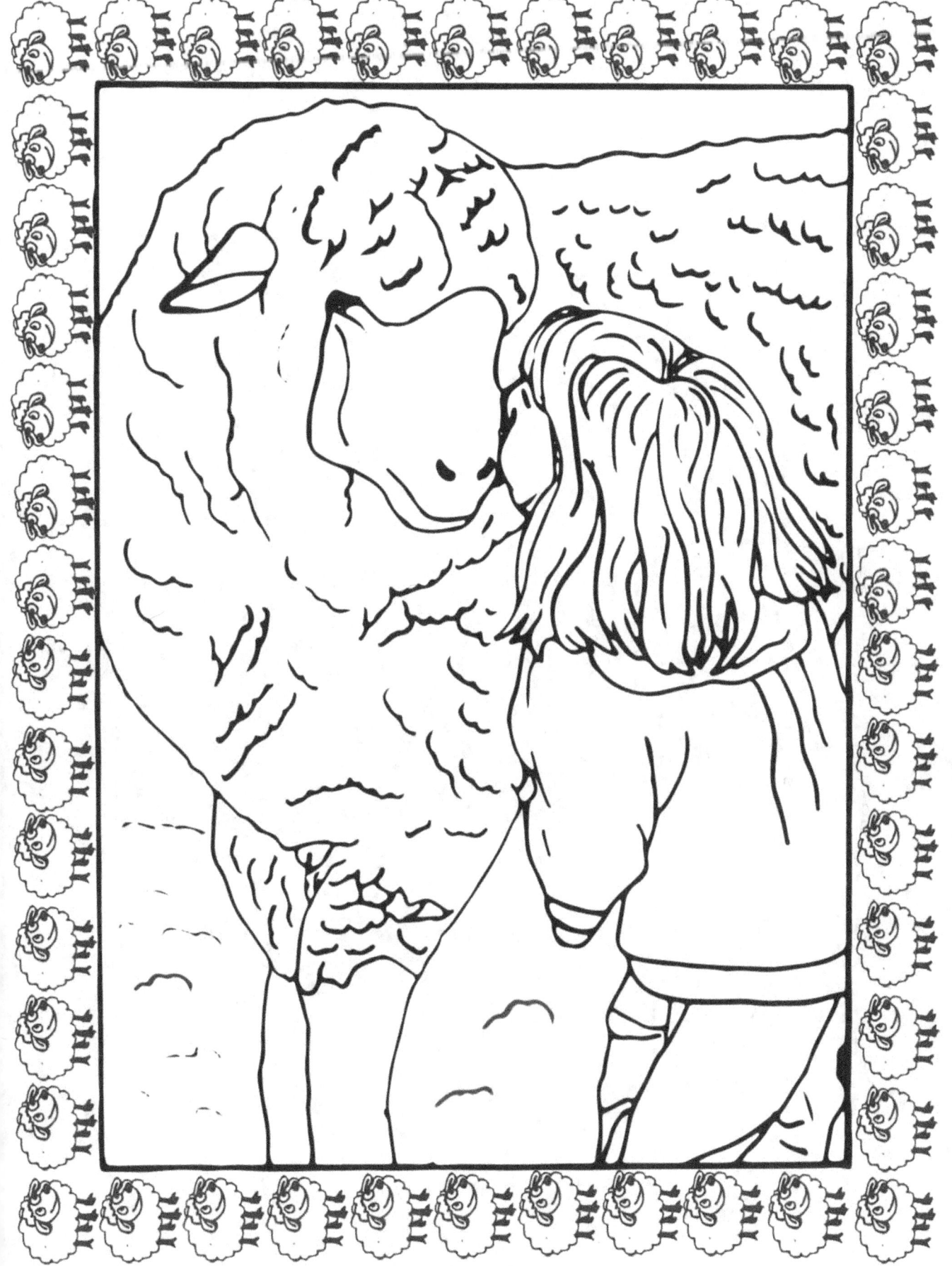

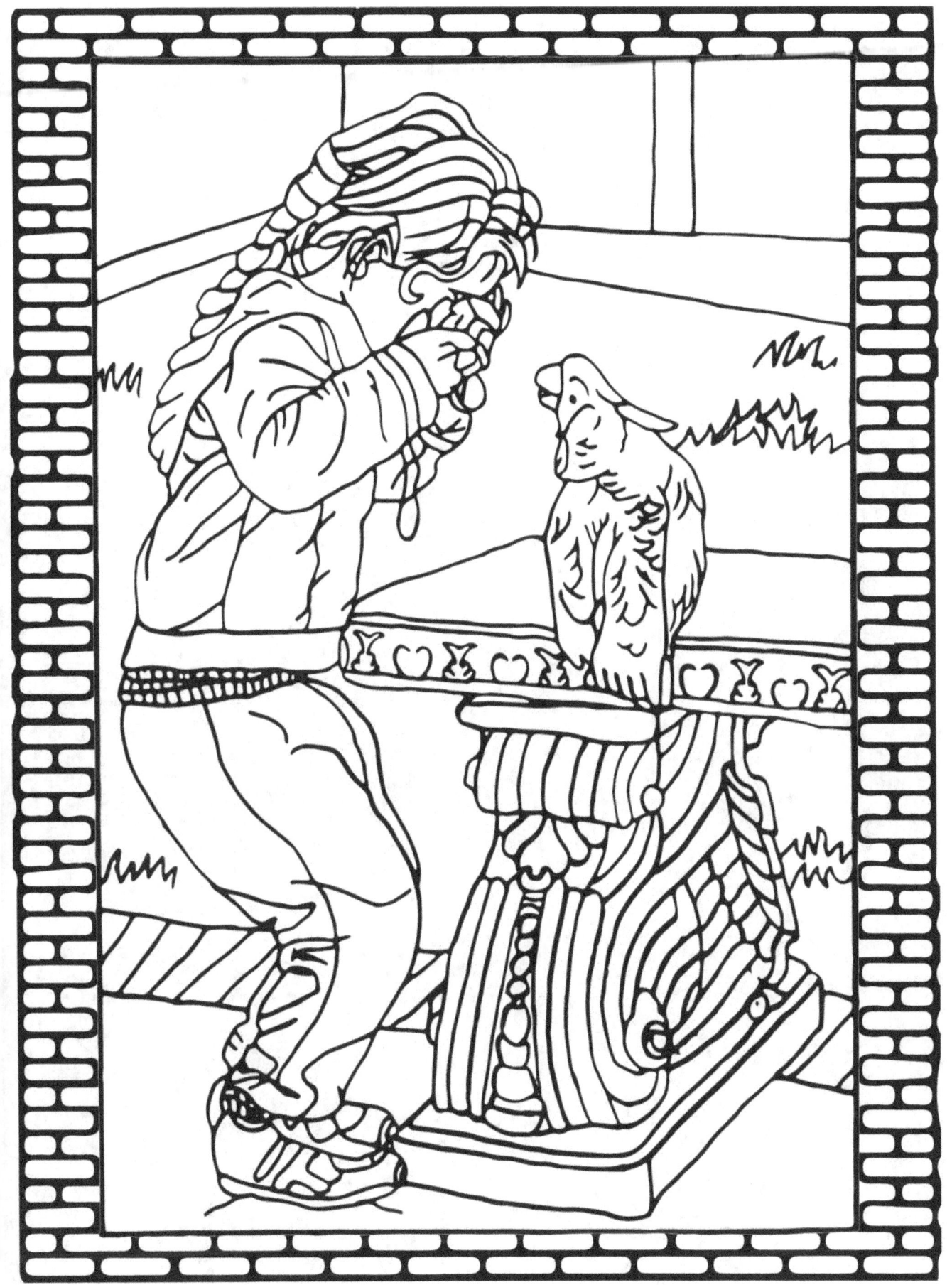

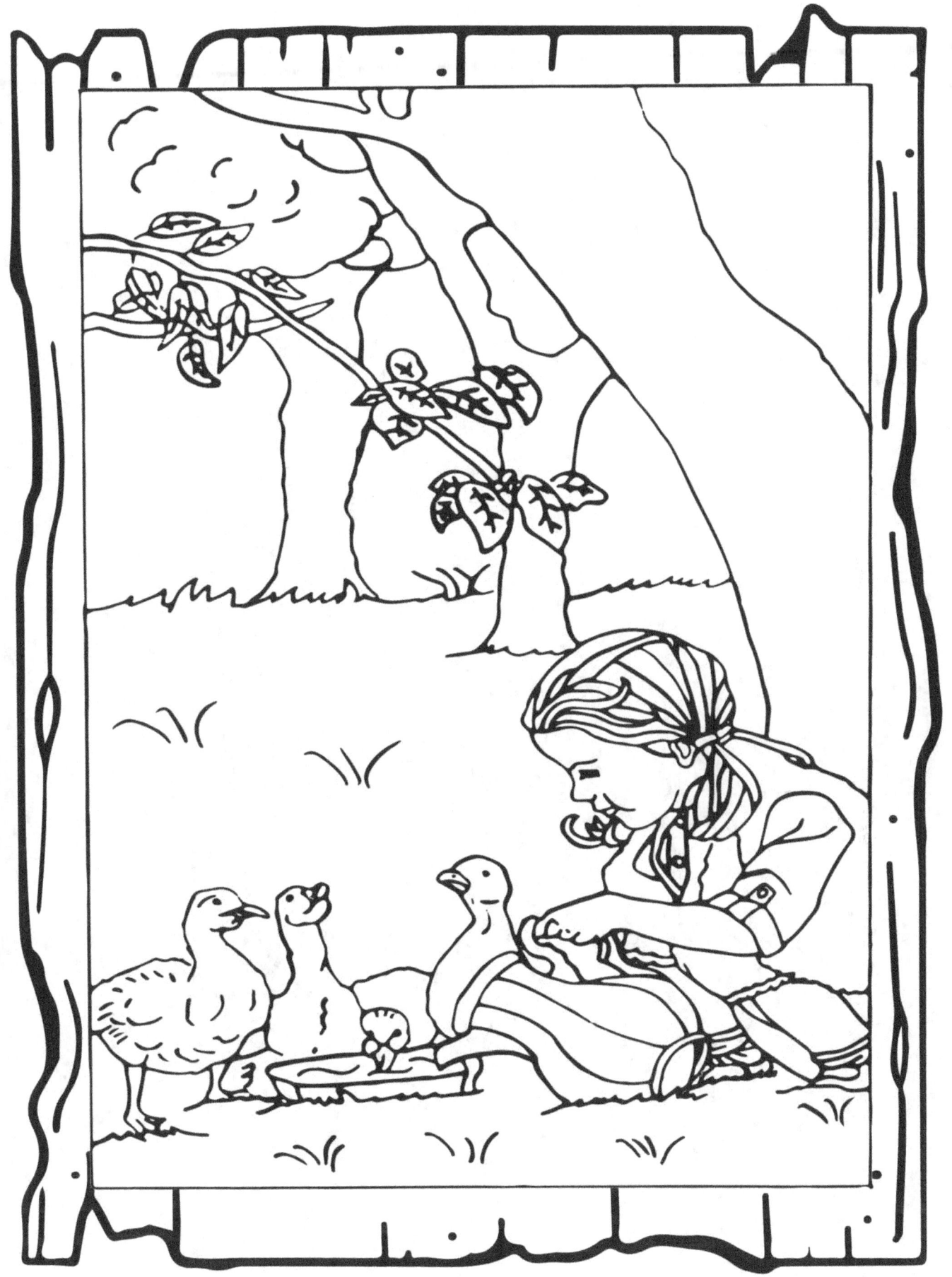

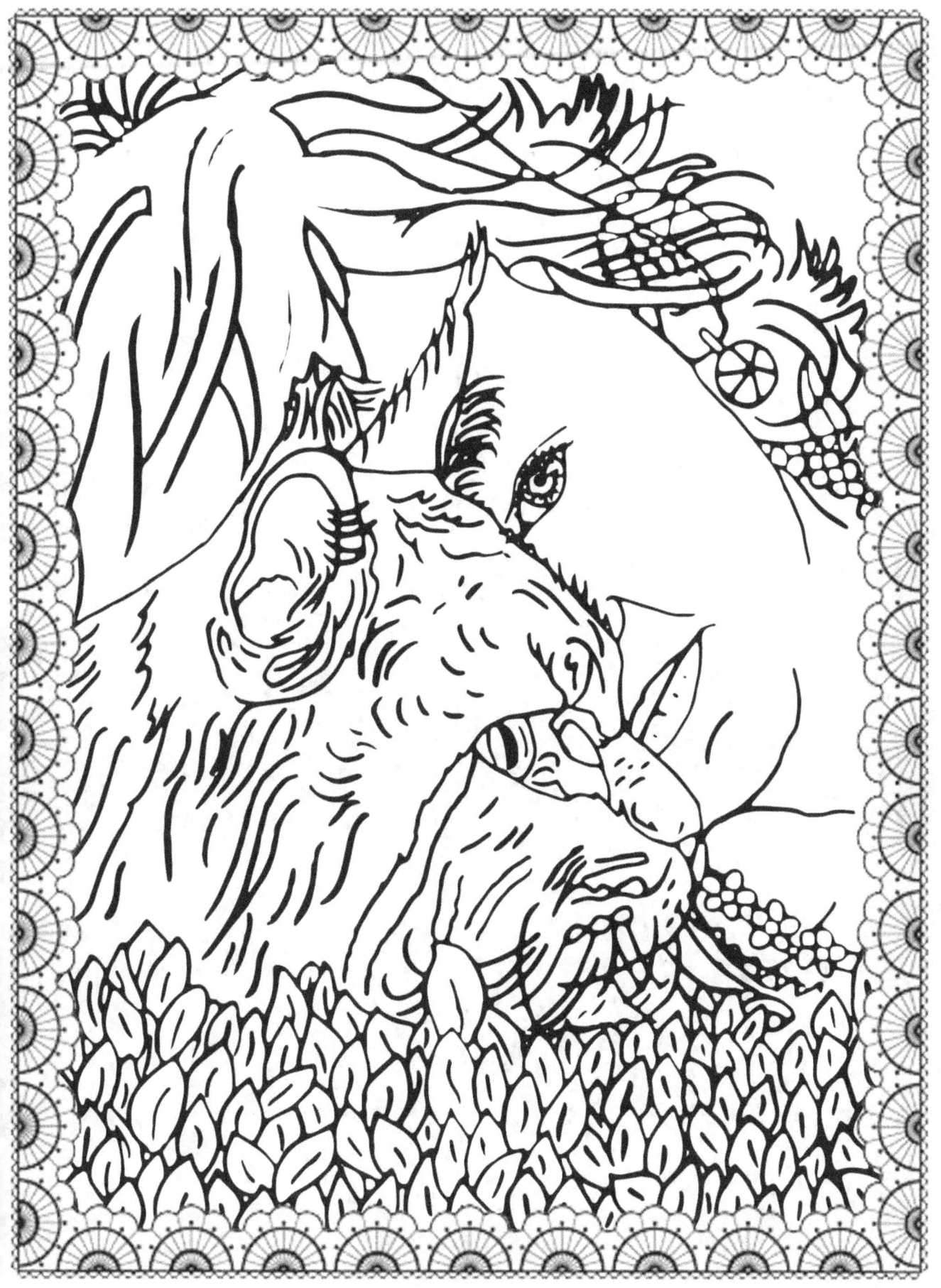

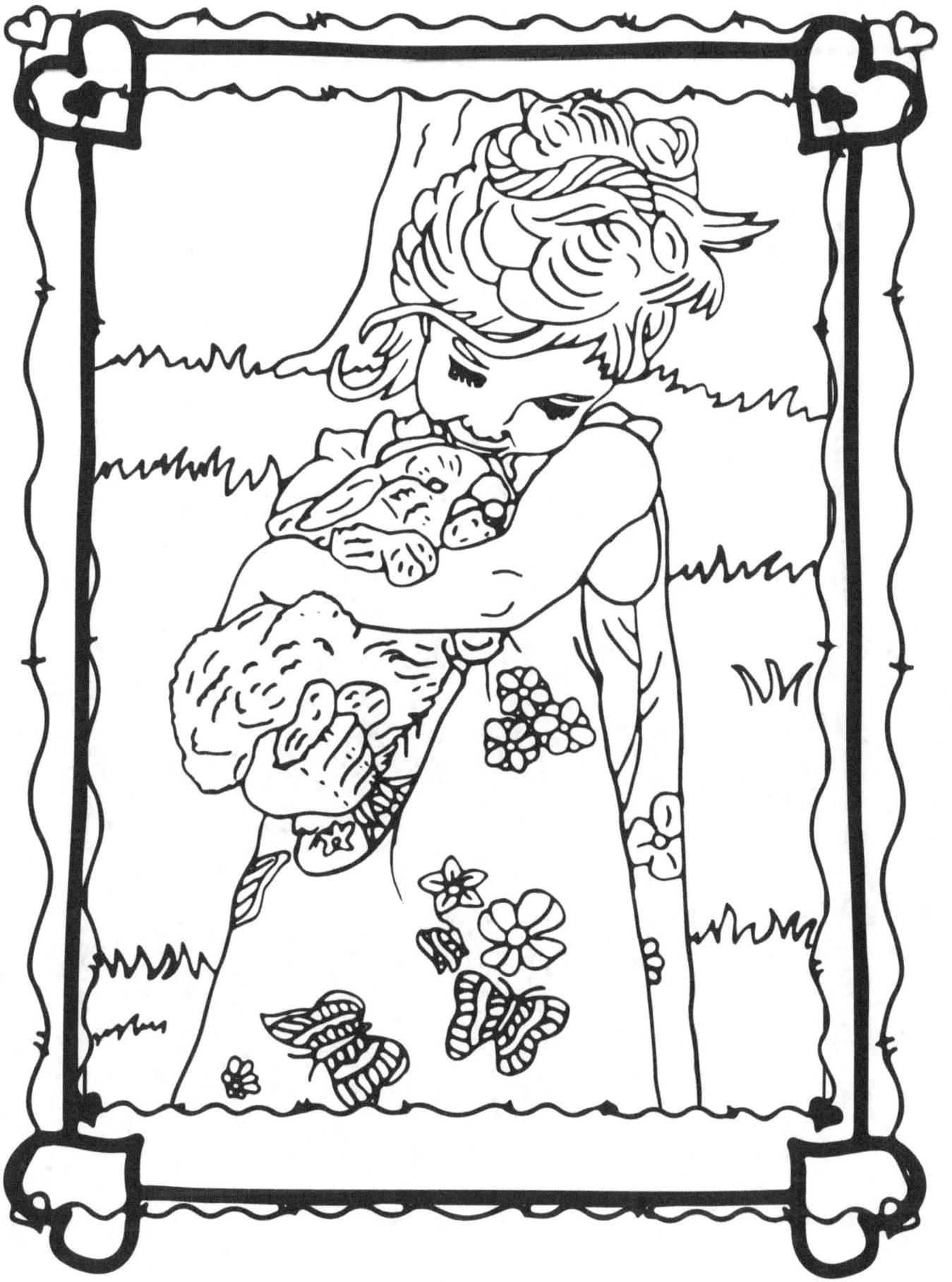

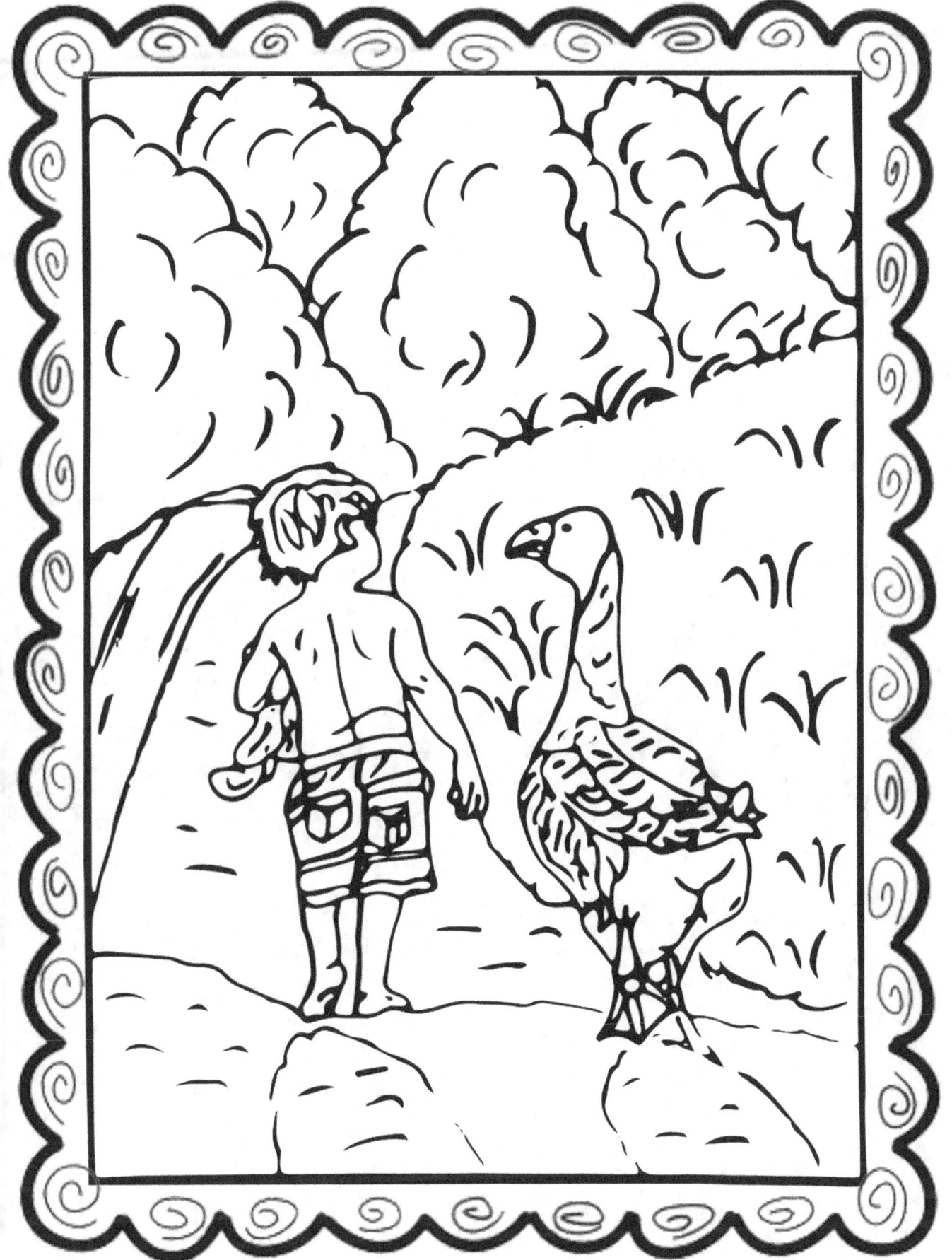

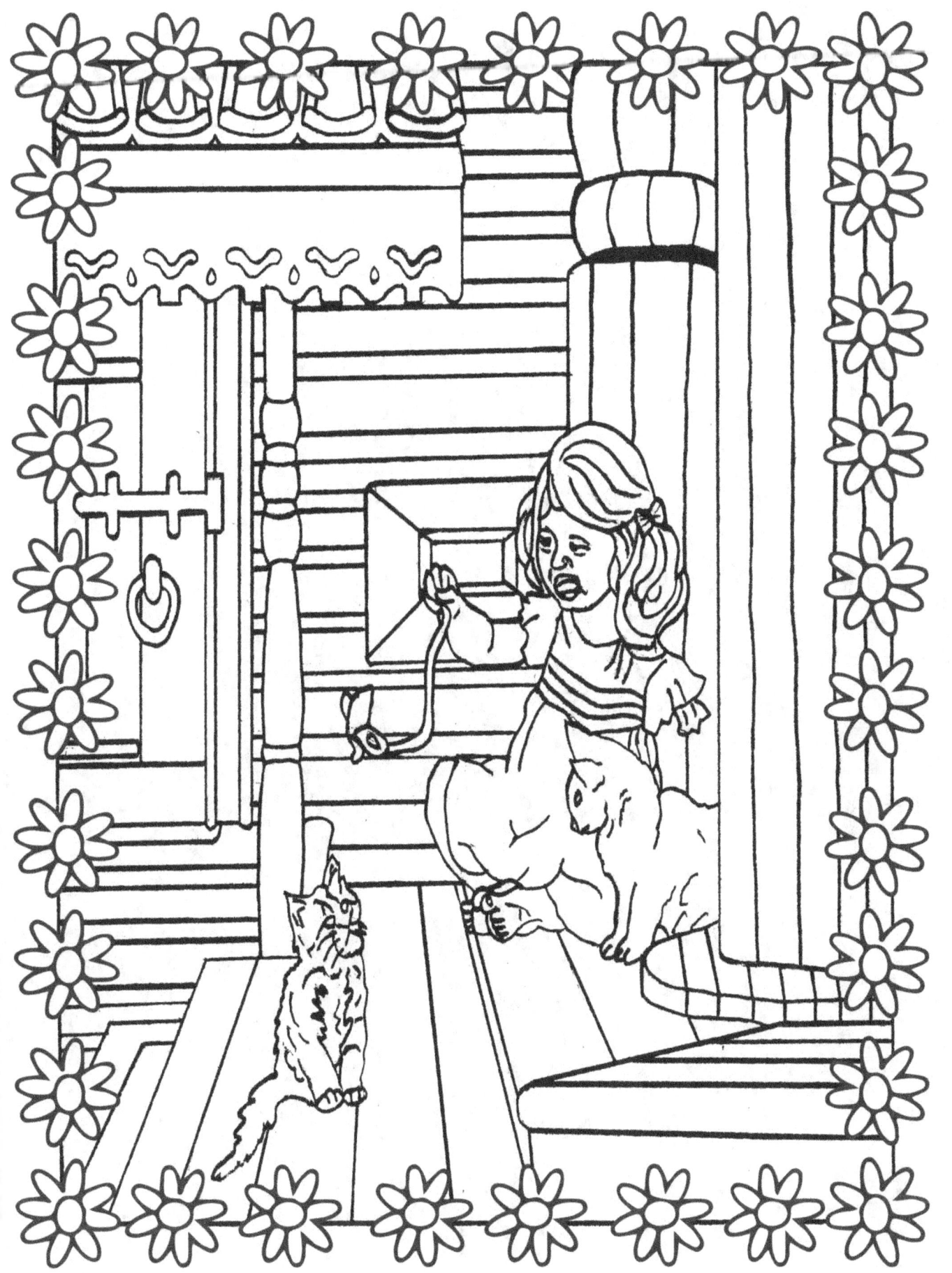

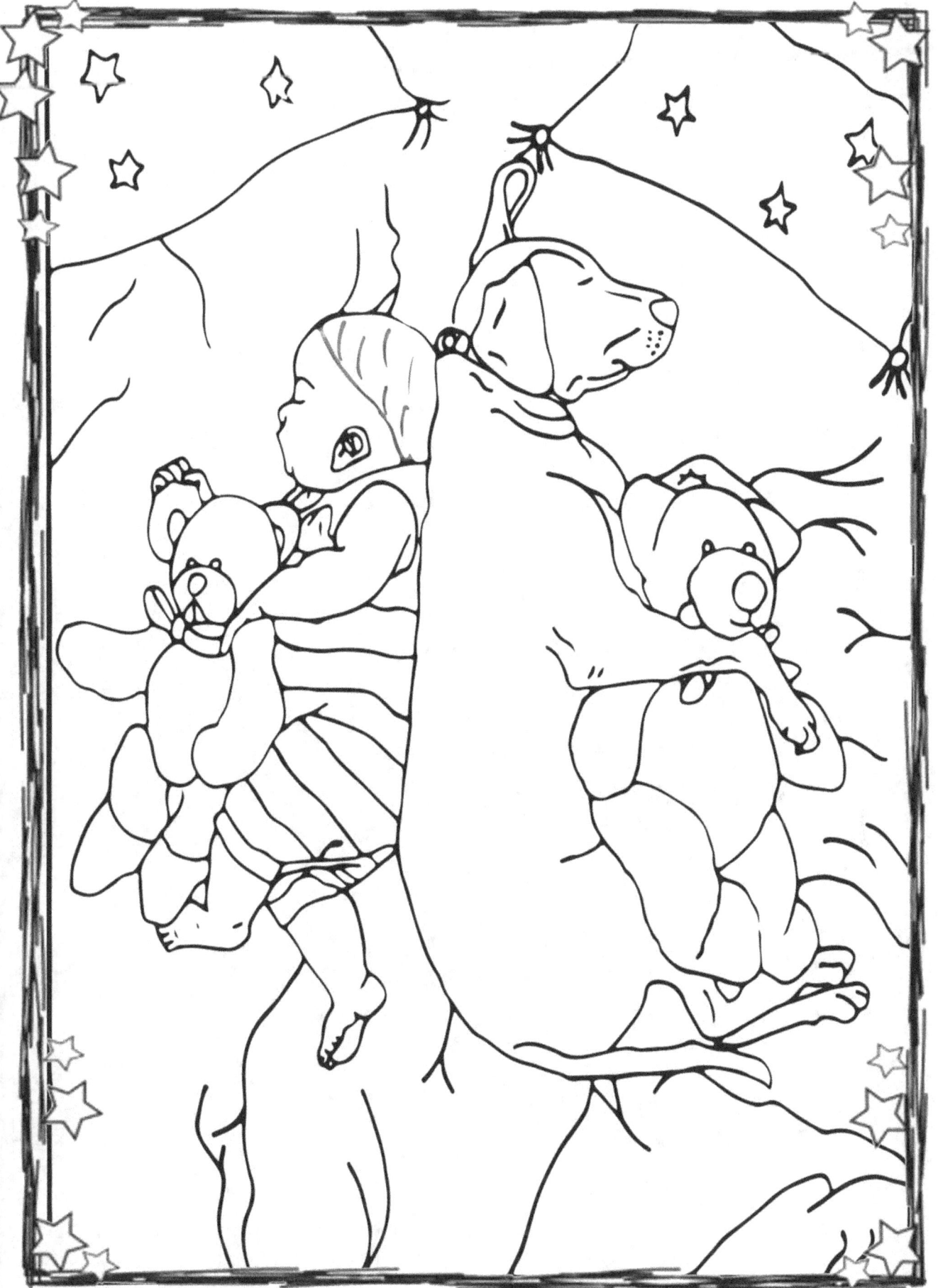

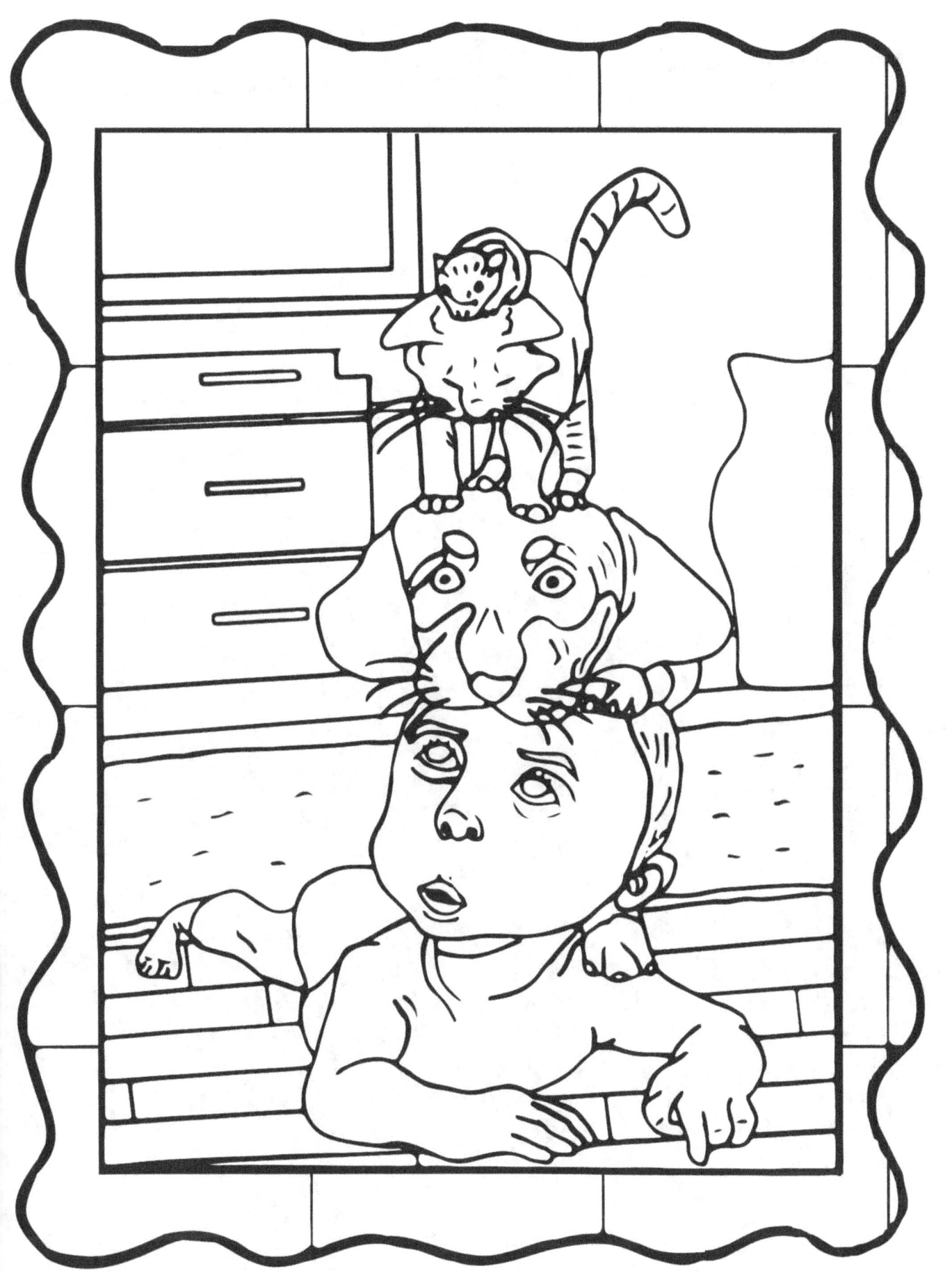

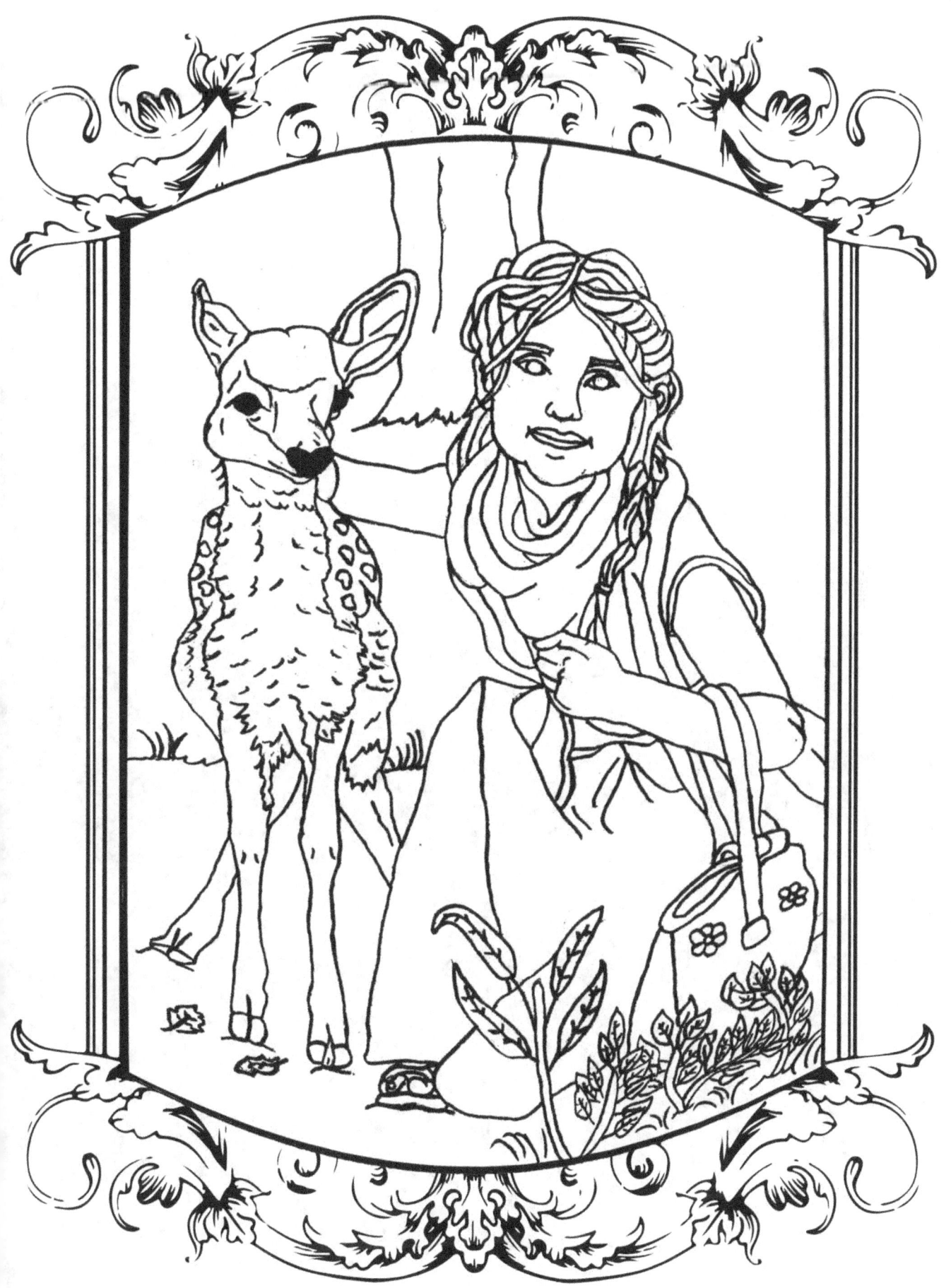

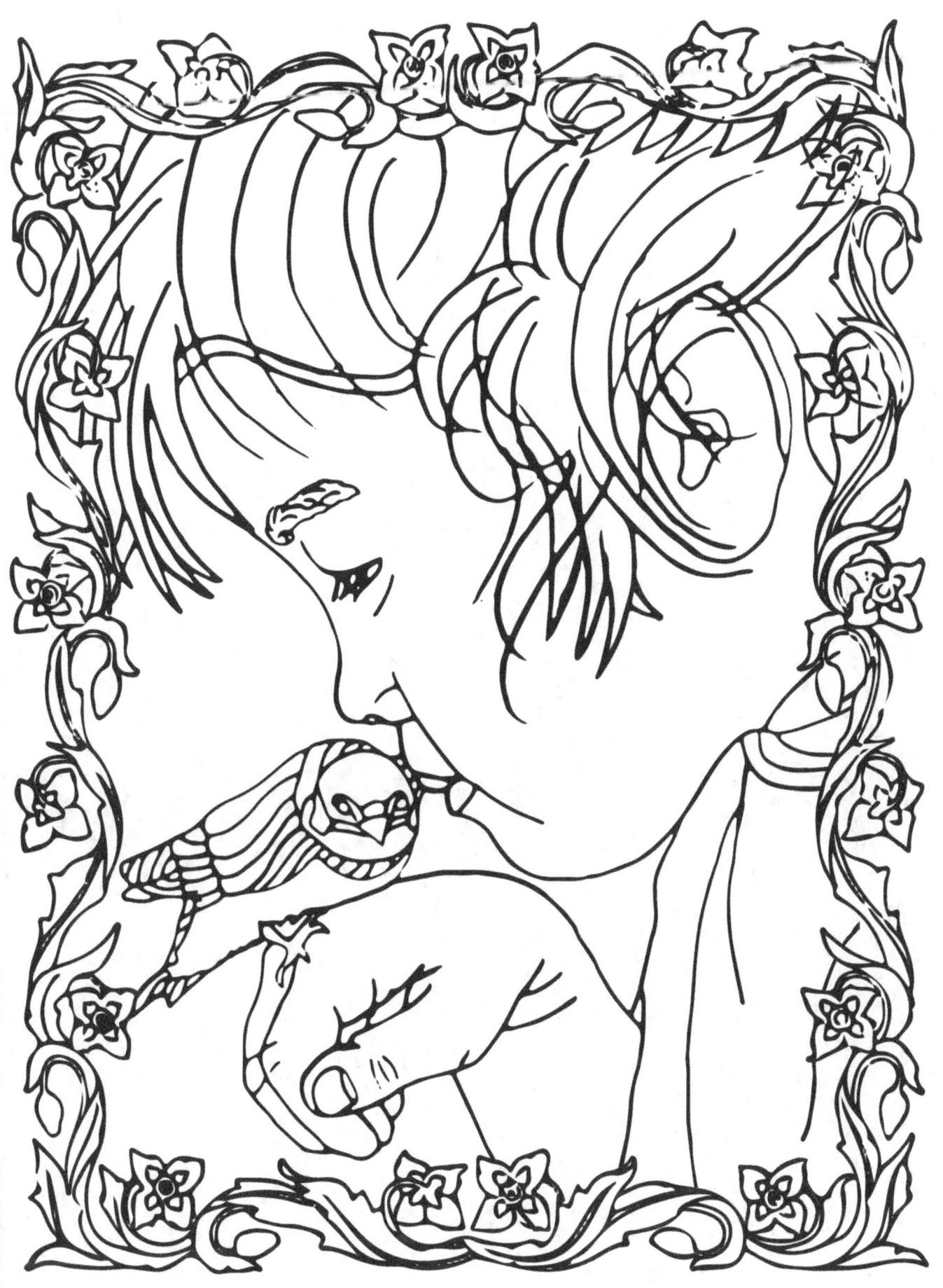

www.ingramcontent.com/pod-product-compliance
Lightning Source LLC
Chambersburg PA
CBHW080229180526
45158CB00008BA/2303